Executive Editor: Bob Nirkind
Production Manager: Sal Destro
Creative Director & Designer: Jason Claiborne, Sublime Visuals
Photo Editor: Jason Santiago
Text Written by Bill Adler
Illustrations by Venus

First published in 2007 by Billboard Books,
An imprint of Watson-Guptill Publications,
A division of VNU Business Media, Inc.,
770 Broadway, New York, NY. 10003
www.watsonguptill.com

Produced by
Watson-Guptill Publications & Augustus Publishing
33 Indian Road, New York, NY 10034
www.augustuspublishing.com

Library of Congress Cataloging-in-Publication Data
The CIP data for this title is on file with the Library of Congress
Library of Congress Control Number: 2006933497

ISBN-10: 0-8230-7974-07885-X
ISBN-13: 978-0-8230-7885-1

Printed in Malaysia

First printing, 2007

1 2 3 4 5 6 7 8 9 / 10 09 08 07

I would like to thank all the people who have supported me throughout my career and made this book possible. First and foremost the artists themselves. I am fortunate to have the opportunity to work with very talented cutting-edge music pioneers . To all the style makers at the labels, Russell Simmons, Lyor Cohen, Andre Hurrell, Sean Combs, Barry Weiss, Ann Carly, Shakim Compare, Irv Gotti, and others who believed in my talent and abilities. To all the magazine editors, Chris Botta, Cynthia Horner, Rudy Meyer, Yvette Noel Shure, and Johnathan Schecter. Thanks to all the publicists and managers for their inexhaustible patience, Lisa Cambridge, Chris Chambers, Lisa Clark, Glynice Coleman, Angelo Ellerby, Serena Gallagher, Kelly Haley, Terry Haskins, Anne Kristoff, Steve Lucas, Jody Miller, Taren Mitchelle, Chrissy Murray, Michelle Murray, Beverly Paige, Jackie Rhinehart, Nat Robinson, Charlie Stettner, Duane Taylor, and Brett Wright. To Philip Heying for all those late-night shoots To Bill Adler, maestro of hip-hop history who curated my first show and spent weeks with me sorting through thousands of photos. To Jason Santiago for his ideas, and to Jason Claiborne for his vision. To my mother, Elyssa, my father, Elias, and my brothers: thank you for always encouraging me. And to my wife, Donna, for being my inspiration.

THE FACES OF HIP-HOP

MICHAEL BENABIB

CHAPTERS

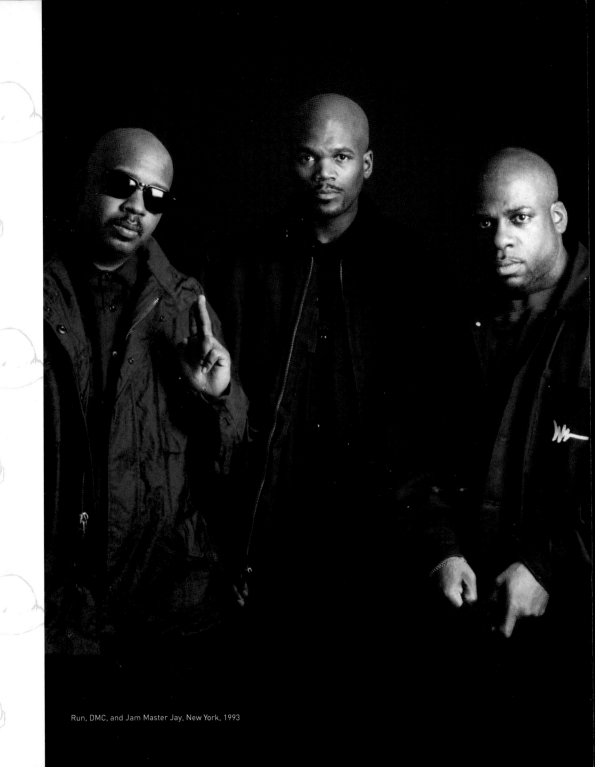

Run, DMC, and Jam Master Jay, New York, 1993

The story of hip-hop is the familiar one of a vital subculture moving from the margins of society into the mainstream. In this case, much of the heavy lifting was done by a battalion of independent rap record labels. The proud and feisty entrepreneurs at the head of these labels, their noses to the ground, were the essential middlemen between the rappers and deejays cooking up the new music in the parks and nightclubs of the Bronx and Harlem, and the giant entertainment conglomerates in midtown Manhattan.

In the very beginning, the two most important indie labels were Sugarhill and Enjoy, both founded by black entrepreneurs with roots in uptown New York and careers in the music business that predated rap by decades. Sugarhill was owned and operated by Joe and Sylvia Robinson, a husband-and-wife team headquartered in Englewood, New Jersey. Sylvia caught the act of a rapping deejay at the birthday party of a friend in 1979 and decided it might be a great idea to make a rap record. Although young people uptown had been rapping for the previous five years and more, it had never occurred to any of the scene's devotees to try to put the music on wax. But this was a natural inspiration for Sylvia, who'd been working in the record business as a singer, songwriter, producer, and indie label exec since the Fifties. She promptly assembled a rap group, dubbed them the Sugarhill Gang, and produced a record called "Rappers Delight." It was an immediate global sensation and launched a run of several years during which it wasn't far-fetched to think of Sugarhill as the Motown of rap.

As the proprietor of Bobby's Happy House, his own record store in Harlem, Bobby Robinson (no relation to Joe and Sylvia) got wind of the new music called rap very early on. To him it was reminiscent of that earlier New York based creative explosion

called doo-wop, and he thought he smelled an opportunity. By 1979, he was producing and releasing great records on the Enjoy label by the Treacherous 3, the Funky Four Plus One, and Spoonie Gee—the same label on which he released sides by King Curtis in the early Sixties.

The success of Sugarhill and Enjoy sparked the creation of a new wave of indie labels run by a younger generation of executives. Tom Silverman and Barry Weiss were steering Tommy Boy and Jive, respectively, by 1981. Cory Robbins and Steve Plotnicki opened Profile in the same year—and two years later gave the world Run-DMC. Russell Simmons and Rick Rubin launched Def Jam in 1984. Eazy E started Ruthless in 1985. Andre Harrell, a protégé of Russell, founded Uptown in 1986, the same year that Chris Schwartz and Joe Nicolo founded Ruffhouse. Ty Williams and Len Fichtelberg opened Cold Chillin' in 1987. Dr. Dre, a protégé of Eazy E, formed Death Row with Suge Knight in 1992. Sean "Puff Daddy" Combs, a protégé of Andre Harrell, launched Bad Boy in 1993.

But these labels, unlike Sugarhill and Enjoy, were not truly independent. Sugarhill and Enjoy had cobbled together their own networks of distribution. Virtually all of the second wave of rap entrepreneurs benefited from distribution by a major label: Tommy Boy and Cold Chillin' hooked up with Warner Bros., Jive and Bad Boy with RCA, Def Jam and Ruffhouse with Columbia, Death Row with Interscope, etc. The only exception was Profile, which stayed independent until it was bought outright by Arista in 1998.

In effect, the indie rap labels acted as talent scouts for the major labels, which were too far removed from the streets to connect directly to the new culture. Here's how Tom

Silverman, on the occasion of Tommy Boy's tenth anniversary, boiled down the indie/major relationship: "I had to identify not what my consumer base had, but what they didn't have. It's easy to see something, but it's very difficult to see nothing. The major labels can only see something, and once they see it, they buy it. They can't create it, because they can't see nothing. Independent labels are down in the low places, so they can see nothing—and everything is created from nothing."

(Along these lines, there's a whole raft of rappers who released their own recordings on their own independent record labels, including Easy E/Ruthless, Too Short/Dangerous Music, Luther Campbell/Luke, Master P/No Limit, and Jay-Z/Roc-a-Fella.)

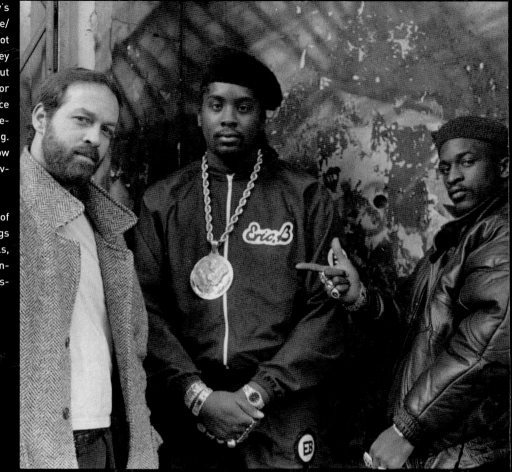

Bill Adler with Eric B. and Rakim, New York, 1988.

Michael Benabib was plunged into the middle of the rap scene from the moment he was hired by *Right On!* and *Source* magazines in 1987. The scene was still so young that there were no national hip-hop publications; *Right On!* (which came into existence in 1971 as a Jackson 5 fan magazine) and *Black Beat* and a few other black music monthlies started to cover rap because it would have been suicidal for them to ignore these potent young artists, who quickly established themselves as the stars of a new generation of black teen music lovers.

Even as he continued to work for magazines, Michael quickly found himself in demand by the indie rap record labels to shoot publicity photos, album cover art, and print ads. In retrospect, he thinks of himself as having been the "unofficial staff photographer" for the Def Jam, Uptown, and Bad Boy labels. And, indeed, when it came time to organize this book, it seemed natural to group Michael's rappers, deejays, singers, producers, and executives according to the labels to which they were attached.

These days, in addition to his hip-hop work, Michael counts advertisers like Heineken, Nissan, and Sprite among his clients. He continues to freelance to the *New York Times Magazine* and *Newsweek*. Looking back, Michael says, "My career and hip-hop's are pretty parallel. As the artists themselves have grown—along with the publications, the recording labels, and the culture's acceptance in the mainstream—so have I."

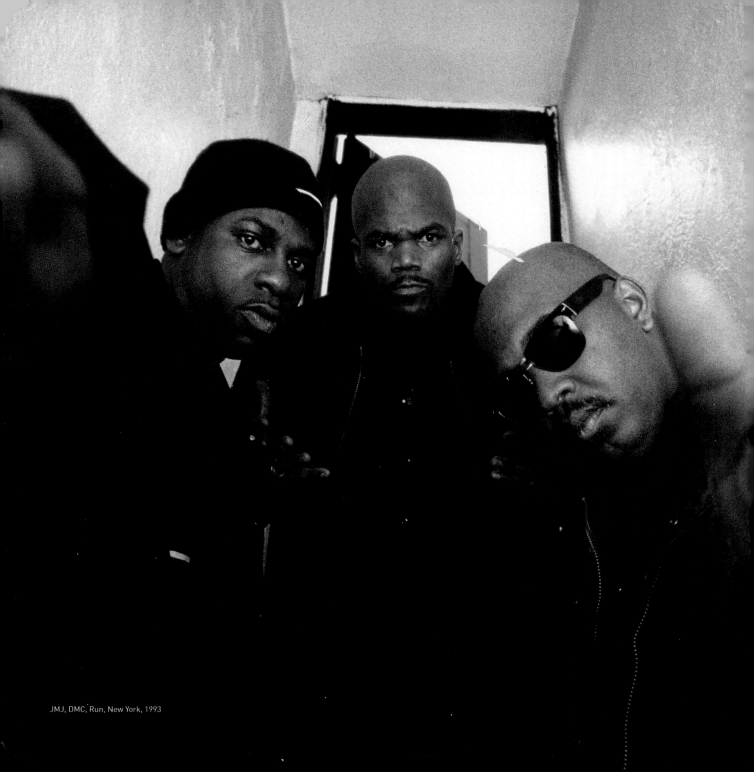

JMJ, DMC, Run, New York, 1993

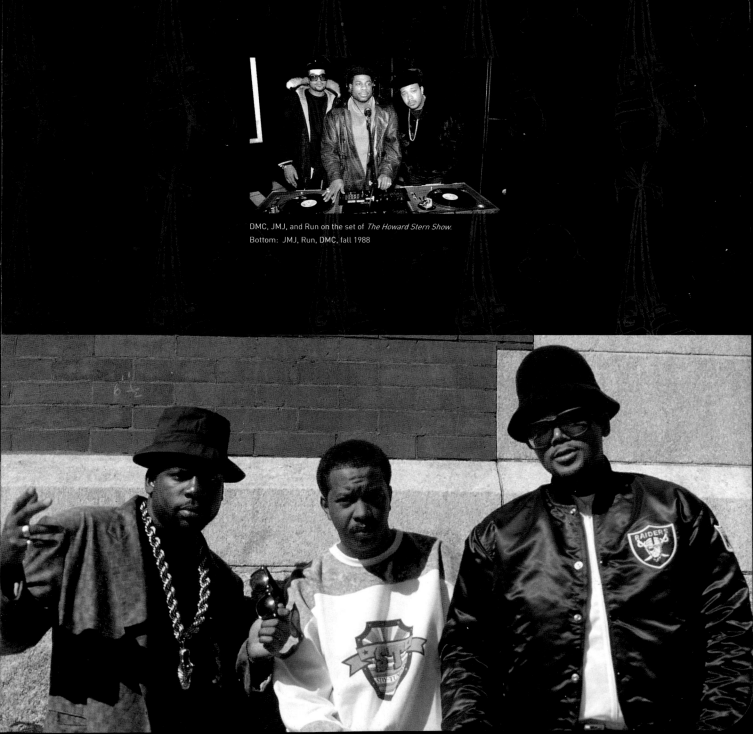

DMC, JMJ, and Run on the set of *The Howard Stern Show*.
Bottom: JMJ, Run, DMC, fall 1988

DEF

Def Jam Recordings was formed in 1984 when Russell Simmons, a hip-hop party promoter, artist manager, and record producer, teamed up with Rick Rubin, an NYU student who'd already produced Def Jam's first release, T. LaRock & Jazzy Jay's "It's Yours." Russ told *Billboard* that the aim of the label was to "put out all those street records that nobody will touch but us."

Def Jam was truly independent only for the calendar year ending in the fall of 1985. During this period they released seven 12-inch singles, including the first titles by LL Cool J and the Beastie Boys. The success of those records was enough to convince Columbia Records, then the largest record company in the world, to go into business with Def Jam. Virtually every rap act Def Jam released in the next several years seemed to go gold or platinum: LL, the Beasties, Public Enemy, Slick Rick, and 3rd Bass.

Russell's Rush Artist Management managed all of the Def Jam artists, and a roster of other hit acts besides, including Kurtis Blow, Whodini, Run-DMC (led by Russell's younger brother Joseph "Run" Simmons), Jazzy Jeff & the Fresh Prince, Eric B. & Rakim, Big Daddy Kane, Stetsasonic, EPMD, and De La Soul. While Russ and Rick concentrated on the label, Rush was put into the capable hands of a hard-charging party promoter from Los Angeles named Lyor Cohen.

By the early Nineties, though, the partnership between Russ and Rick had soured. Rick left Def Jam and moved to L.A. to form the Def American label, Russ started concentrating on his Phat Farm fashion line and *Def Comedy Jam* television show . . . and Lyor

took over the reins at Def Jam. Indeed, Lyor oversaw a second golden age at Def Jam, thanks to new discoveries like Redman, Method Man, Jay-Z, DMX and the Ruff Ryders posse, and Ja Rule. In 2004, Lyor left Def Jam for Warner Bros. and Jay-Z became president of the label.

DEF

RUSH

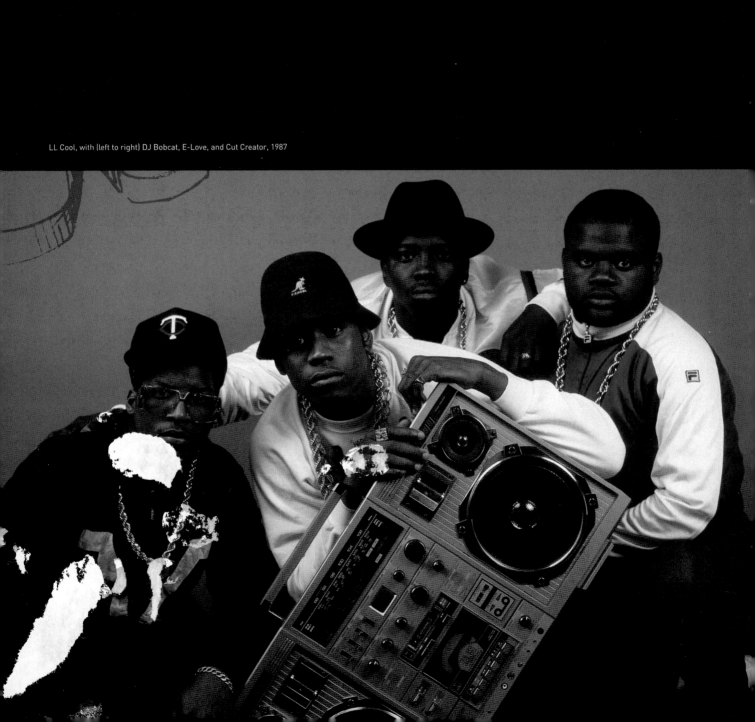

LL Cool, with (left to right) DJ Bobcat, E-Love, and Cut Creator, 1987

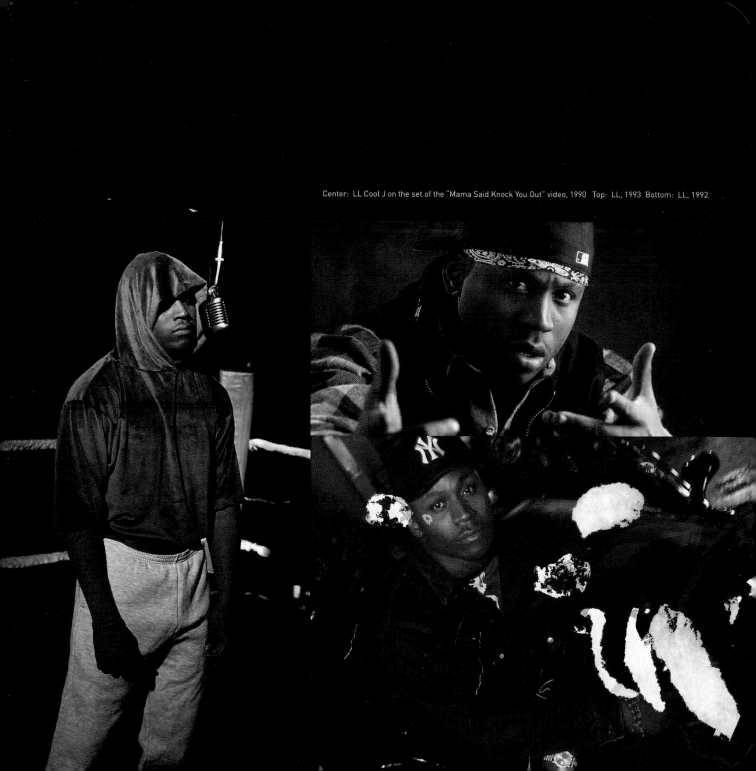

Center: LL Cool J on the set of the "Mama Said Knock You Out" video, 1990 Top: LL, 1993 Bottom: LL, 1992

Above: Slick Rick (in yellow). 1991
Facing Page: Slick Rick (detonating color). 1991

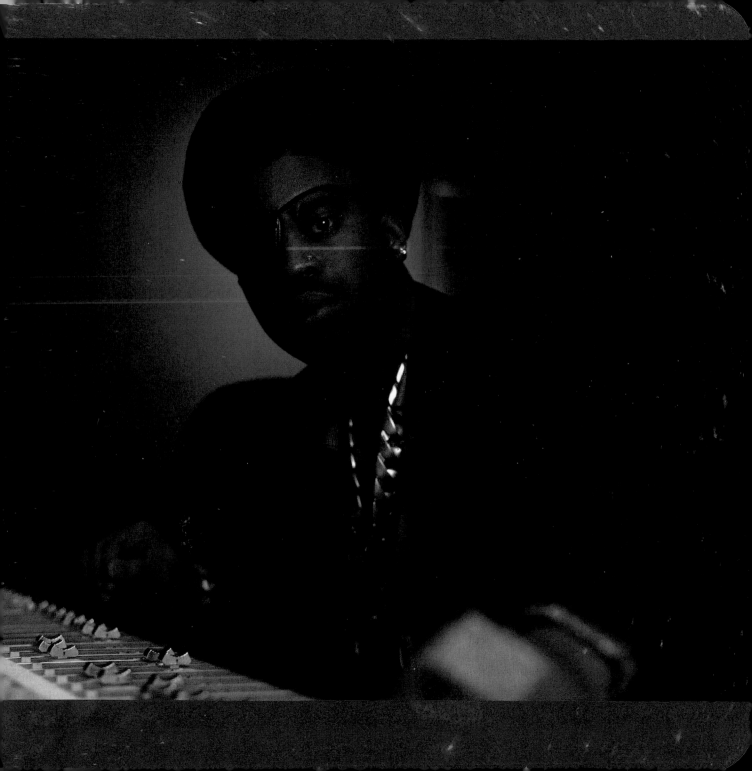

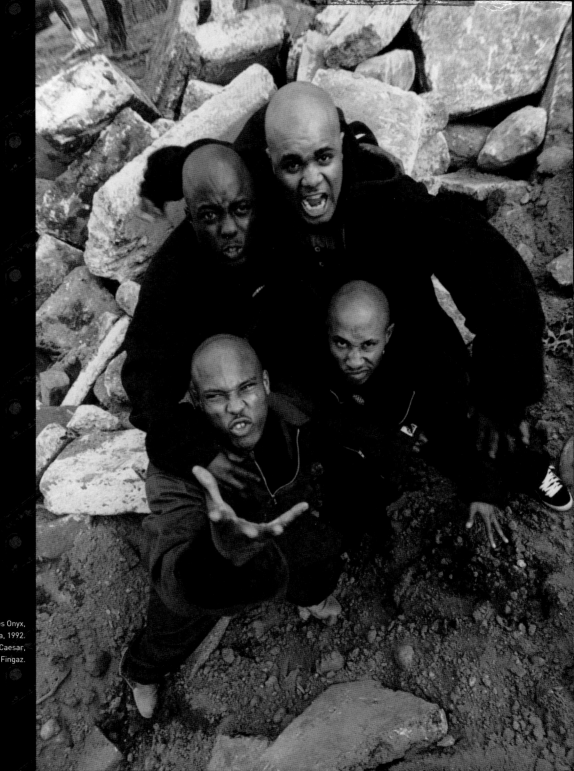

Jam Master Jay's protégés Onyx,
"Throw Ya Gunz" era, 1992.
Clockwise from top left: Suave Sonny Caesar,
Big DS, Fredro Starr, and Sticky Fingaz.

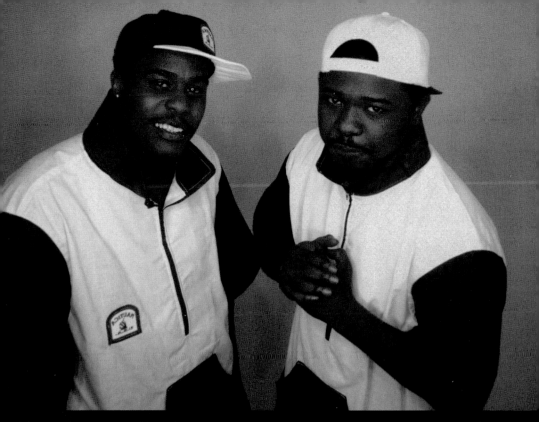

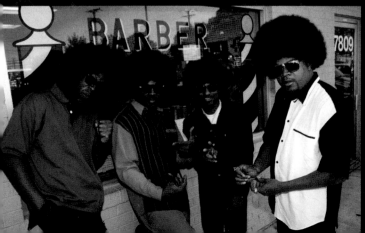

Smooth B and Greg Nice of
Nice & Smooth, 1994

Jam Master Jay's protégés The Afros,
Washington, DC, 1990.
From the left:
Kool Tee, Kippy-O, Hurricane.

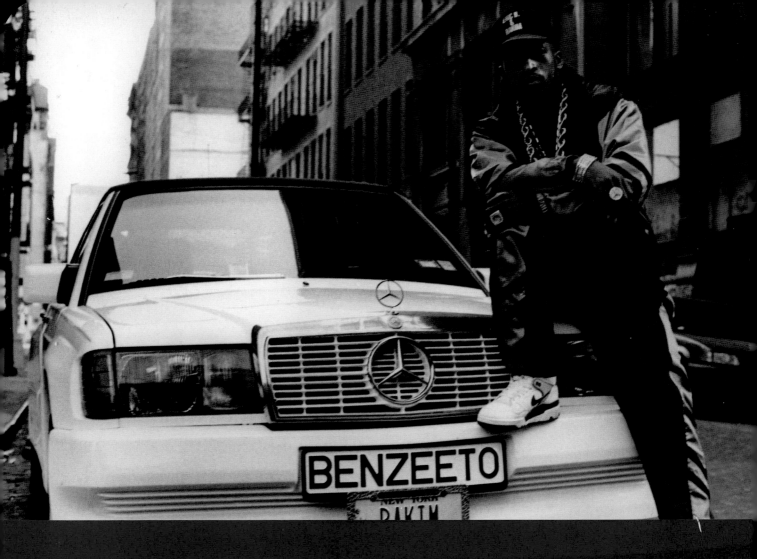

Above: Rakim and his Benzeeto, Bleecker Street, New York, 1988

Facing page, top: Eric B & Rakim, New York, 1988
Bottom left: Eric & Ra on the set of the "Casualties of War" music video, New York, 1992
Bottom middle: Eric and Ra shooting the video for "Juice (Know the Ledge)," 1992.
Bottom right: Eric B. and a young friend , New York, 1988

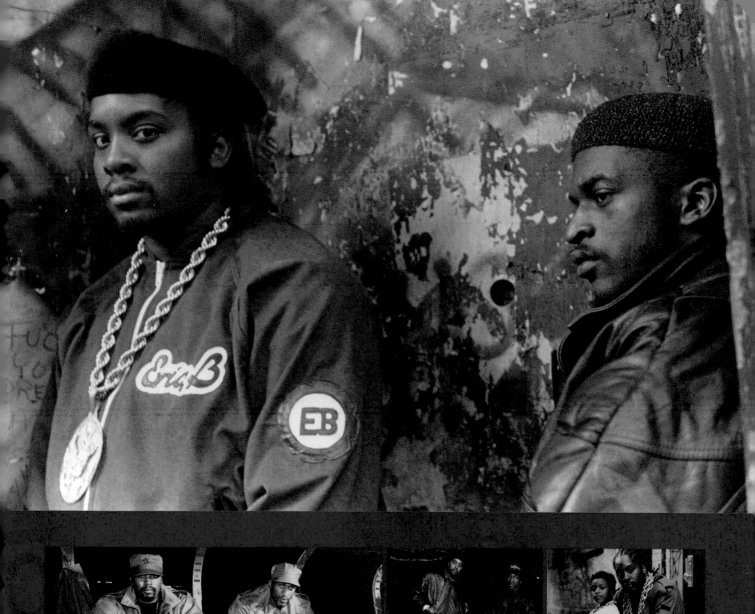

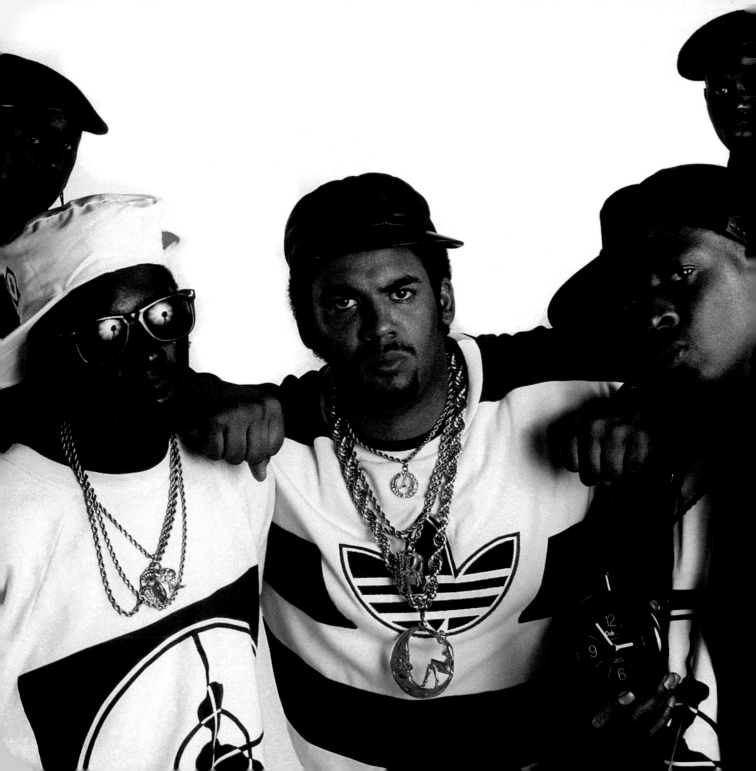

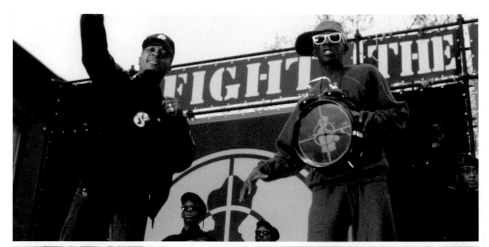

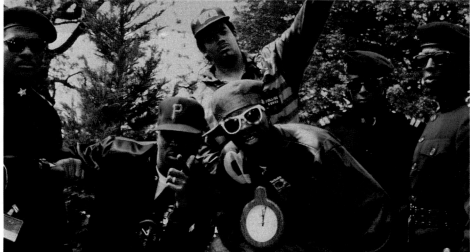

Left: Public Enemy 1987,
Professor Griff, Flavor Flav, Terminator
X, Chuck D, and Brother James.

Top: Public Enemy making the
Spike Lee–directed video for
"Fight the Power," Brooklyn, 1989
Middle: On the set of
"Brothers Gonna Work It Out," 1990
Bottom: On the set of
"Brothers Gonna Work It Out," 1990

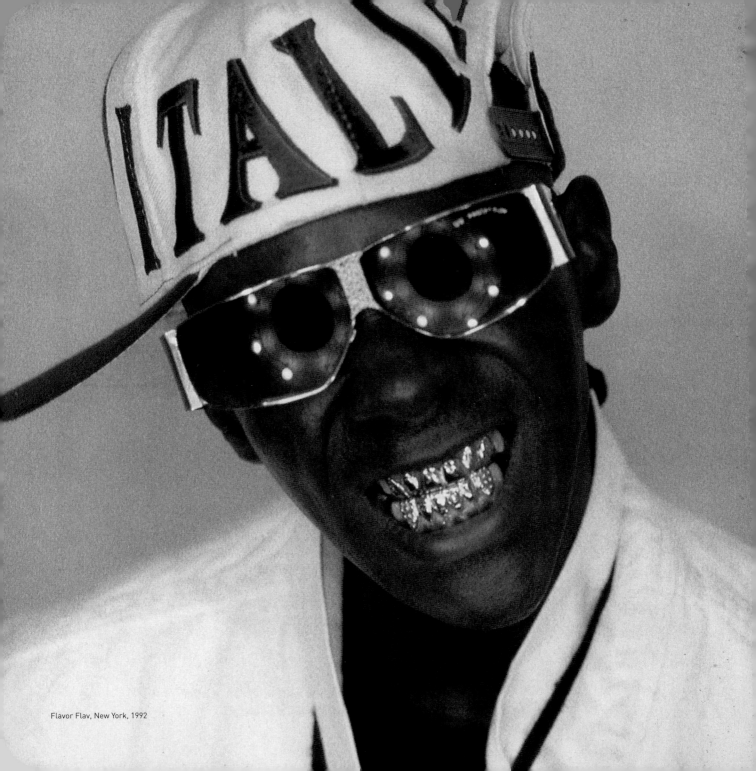

Flavor Flav, New York, 1992

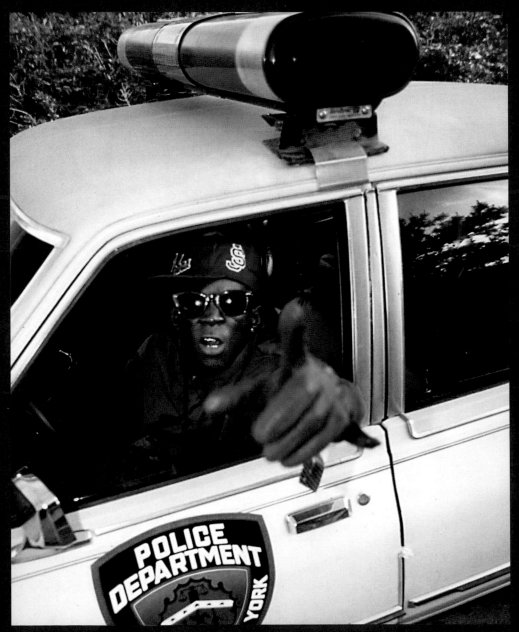

Flavor Flav making the video for "Bruthas Gonna Work It Out," Long Beach, NY, May 1990

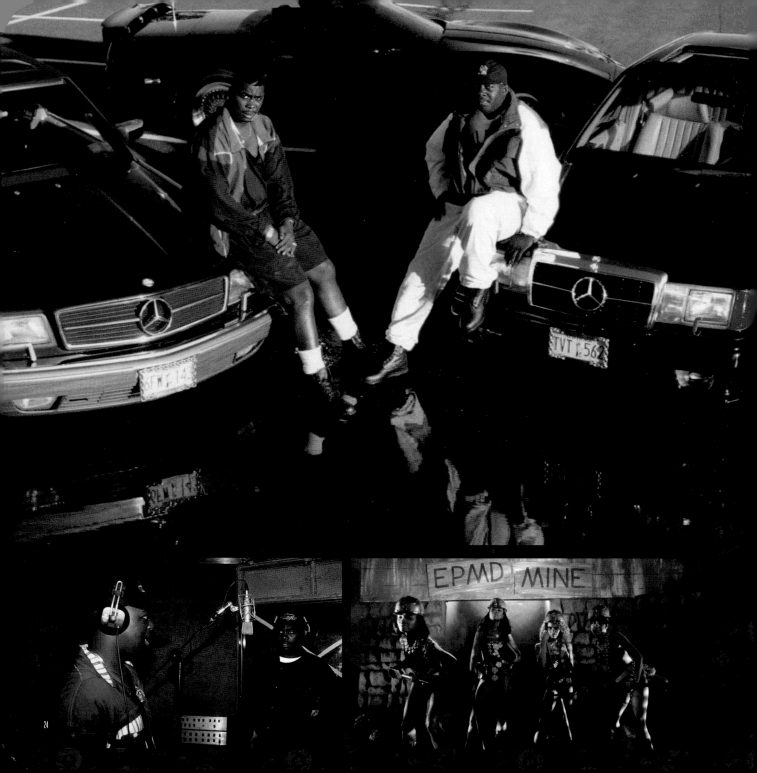

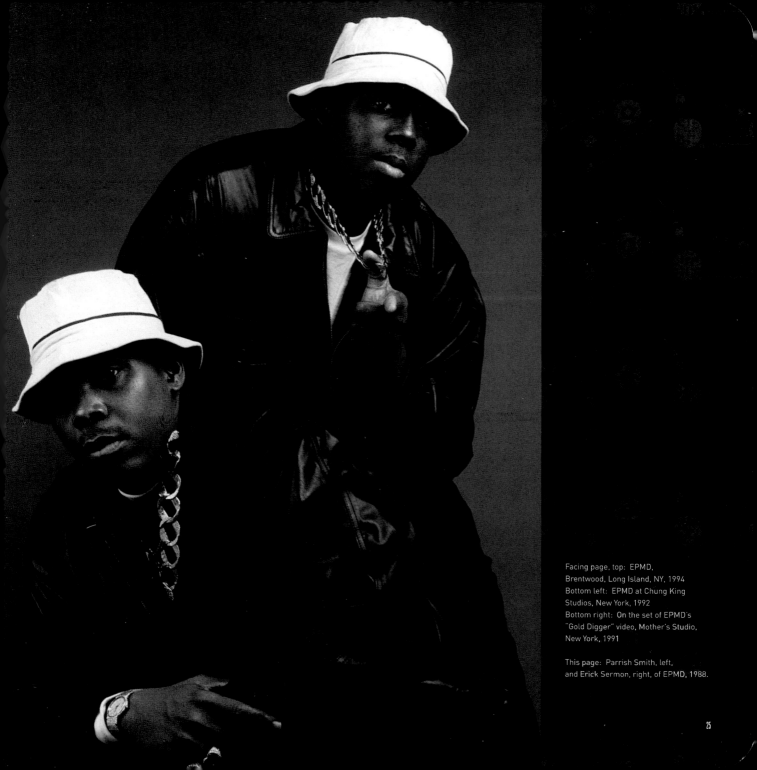

Facing page, top: EPMD,
Brentwood, Long Island, NY, 1994
Bottom left: EPMD at Chung King
Studios, New York, 1992
Bottom right: On the set of EPMD's
"Gold Digger" video, Mother's Studio,
New York, 1991

This page: Parrish Smith, left,
and Erick Sermon, right, of EPMD, 1988.

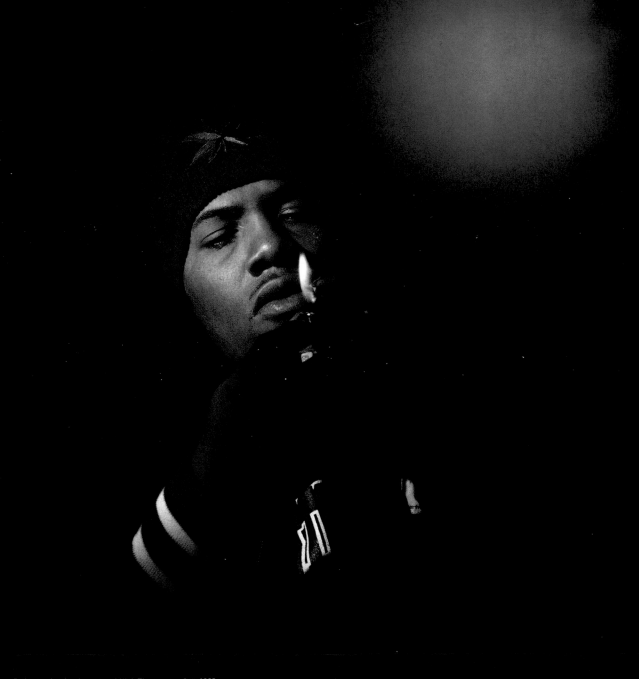

Redman, shot for the cover of *High Times* magazine, 1993.
Facing page: Erick Sermon, during the release of *Double or Nothing*, 1995

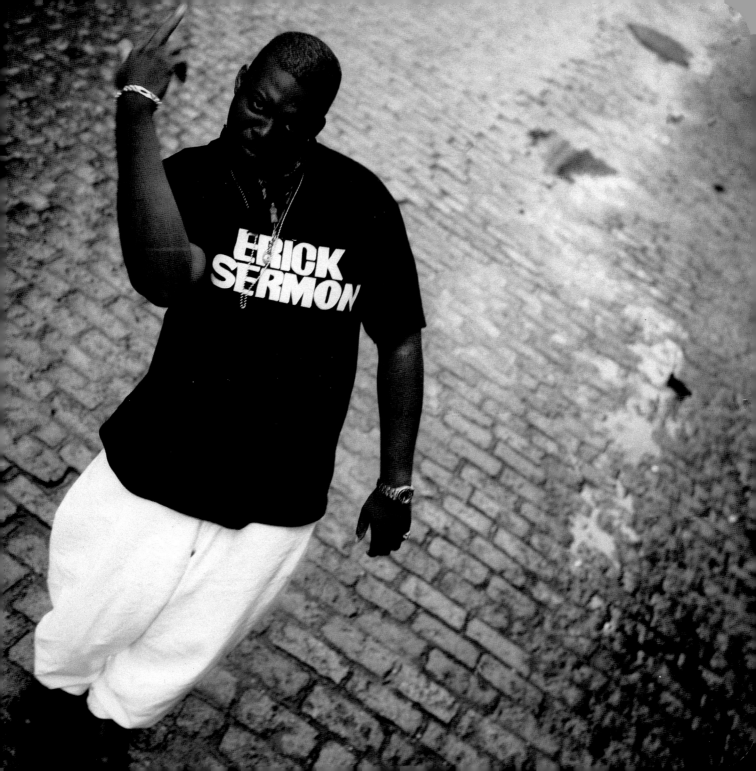

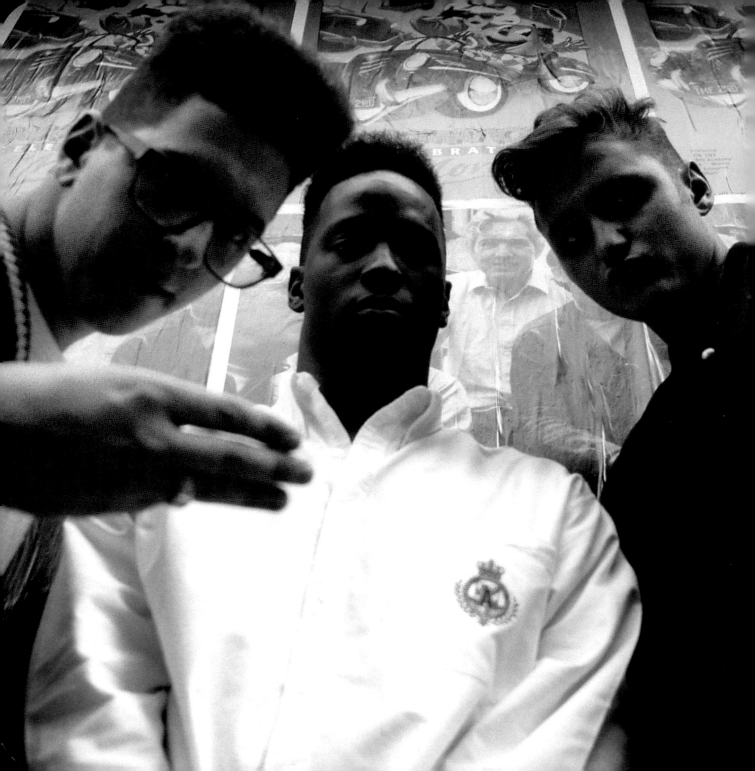

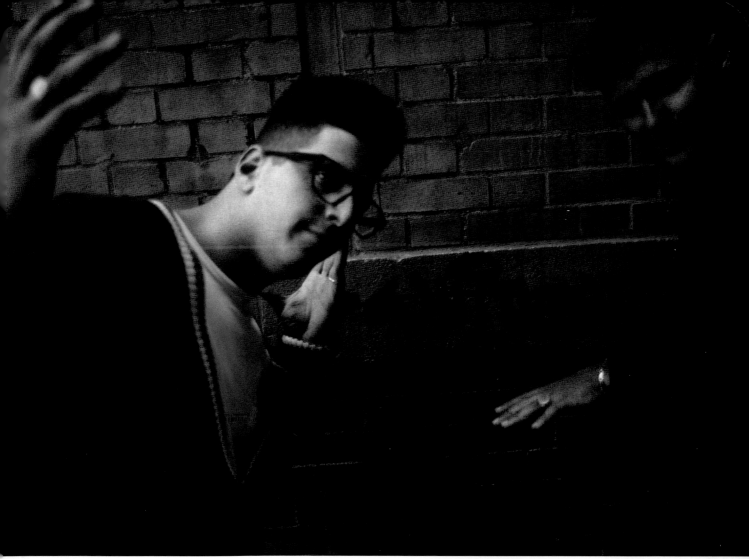

Facing page: 3rd Bass—MC Serch, DJ Richie Rich,
Pete Nice—New York, c. 1989

Top: Serch and Pete, corner of Lafayette
and Bond, New York, 1989
Bottom left: Serch from behind, 1989.
Bottom right: Serch and Pete on the set of
"The Gas Face" video, 1989

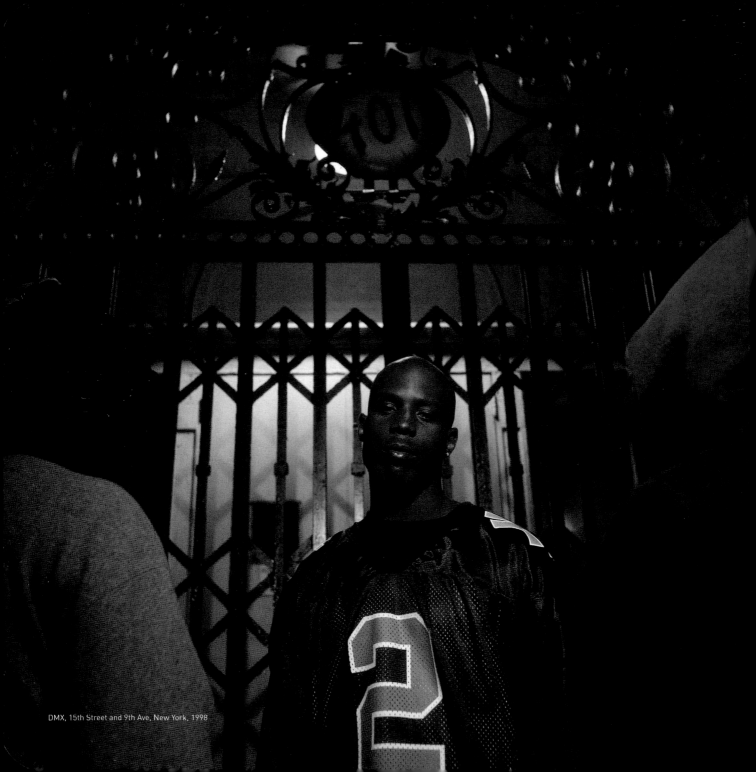

DMX, 15th Street and 9th Ave, New York, 1998

Top left: Eve, Los Angeles, 1999
Top right: Wink 1100 of the Ruff Ryders,
Randall's Island,1998

Bottom left: Swizz Beatz, Los Angeles, 1999
Bottom right: Menphis Bleek, left, Ja Rule,
center, Beanie Sigel, right.

Above: Russell Simmons, New York, 2001
Left: Russell Simmons and Andre Harrell,
Def Jam Christmas Party, New York, 1990.
Center: Russell Simmons and the Real Roxanne,
Def Jam Christmas party, New York, 1989.
Right: Kimora Lee Simmons, New York, 2001

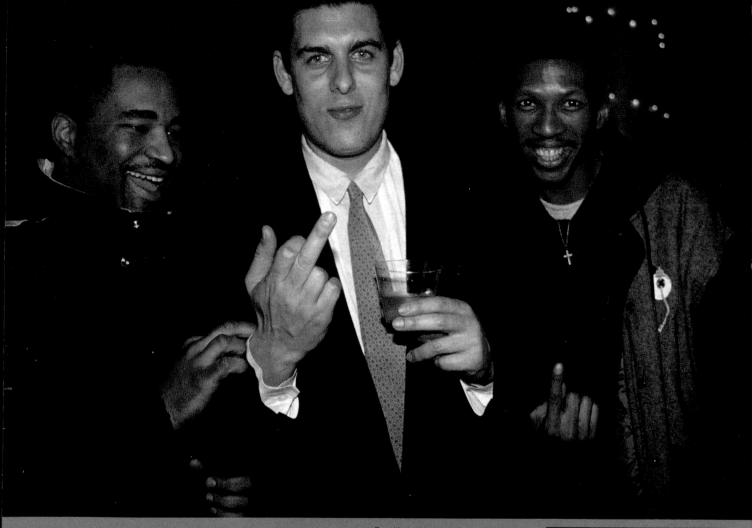

Top: Marley Marl, Lyor Cohen, Hank Shocklee,
Def Jam Christmas Party, 1991.
Bottom: Nikki D and Chuck Chillout,
Chung King Studios, New York, 1988.

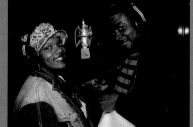

UPTOWN

Bronx-born Andre Harrell founded Uptown Records after coming to the end of the road as the front-half of Dr. Jeckyll & Mr. Hyde, a dapper duo who billed themselves as "the suit-and-tie rappers" and were managed by Rush. Distributed by MCA, the label's first star was Dwight Myers, a/k/a Heavy D, a/k/a the Overweight Lover, a Jamaican-born rapper who'd grown up in Mount Vernon, New York. Andre was taken by Heavy's likability; he dreamed of the rapper replacing Jackie Gleason as "the fat man America loves." This was consistent with Andre's desire to create a middle ground between the hardcore rap of Def Jam and the cozier R&B of the day.

Heavy D & the Boyz gave Uptown its first hit in 1986. A few years later, Heavy convinced Andre to hire an old boyhood pal of his from Mt. Vernon as an intern. This was the very talented and ambitious Sean "Puff Daddy" Combs, whose stint at Uptown saw him rise from intern to promo man to superstar producer in the space of a couple of years. As the producer of Uptown's multiplatinum albums for Jodeci and Mary J. Blige, Puffy did Andre's bidding by figuring out how to make R&B relevant in the age of rap.

But Puff yearned to get involved with the harder stuff. He signed a promising Brooklyn rapper named Biggie Smalls, but was fired by Andre in 1993 because Uptown just wasn't big enough for the two of them. Andre himself left Uptown in 1994 to become the CEO of Motown Records. Heavy D stepped in as the president of Uptown and oversaw the success of Soul 4 Real. The label was dissolved in 1996.

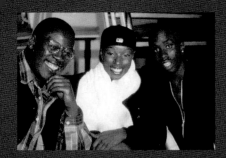

Above: Andre Harrell, Mary J. Blige, and
Puff Daddy on the set of the "Love No Limit" music
video, 1993.

Right: Andre Harrell, New York, c. 1991

Facing page:
An Uptown Records family portrait, 1992. Andre
Harrell is seated; MJ Blige is to his left. One of one of
the Boys and Eddie F. Father MC Christopher Williams
is to his right. Heavy D is immediately behind him.
Jodeci occupies the right side of the frame. Their pro-
ducer, a young Puff Daddy, is in the top right corner.

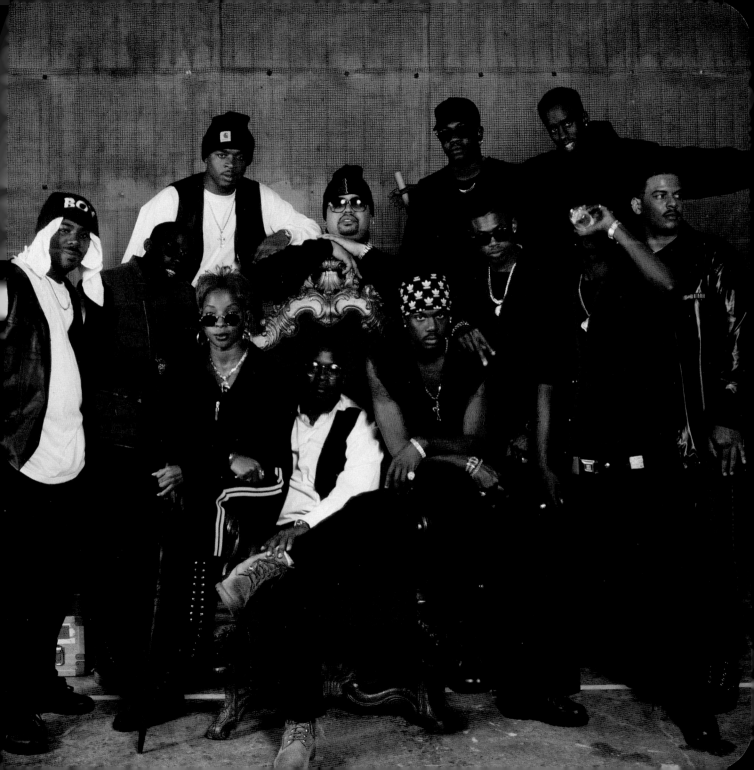

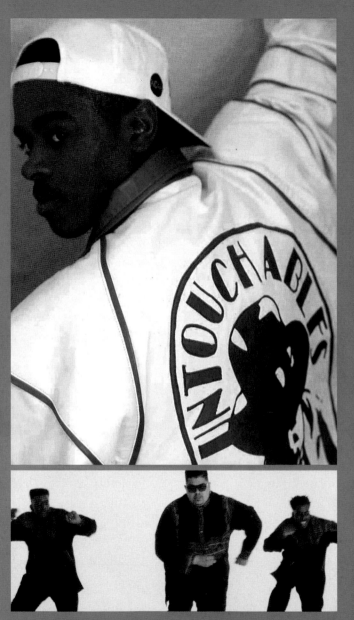

Top: DJ Eddie F., producer and member
of Heavy D & the Boyz, c. 1992
Bottom: Heavy D & the Boyz on the set of the
"We Got Our Own Thang" video, New York, 1989

Facing page: Heavy D on the set of the "Nuttin' But Love" video, 1994

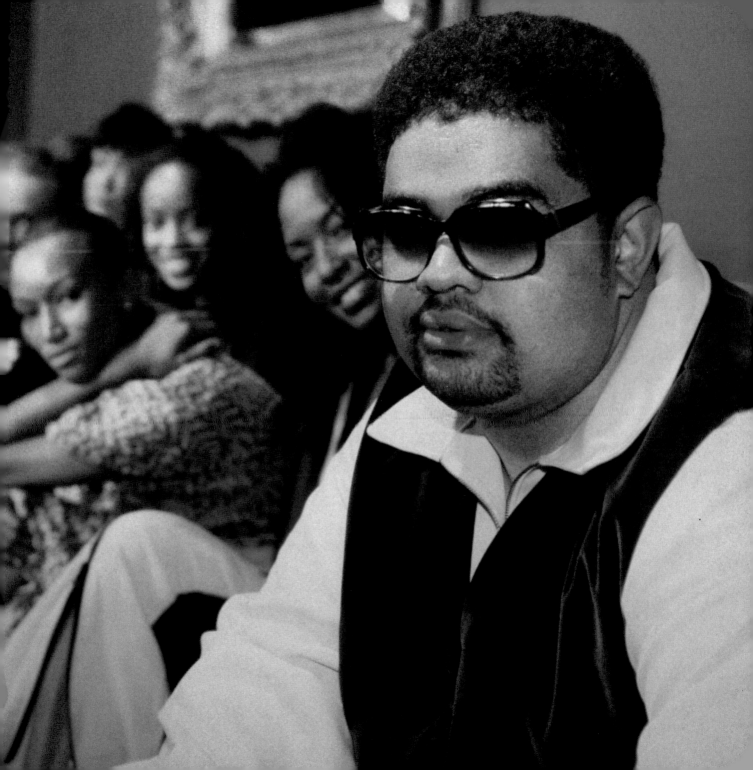

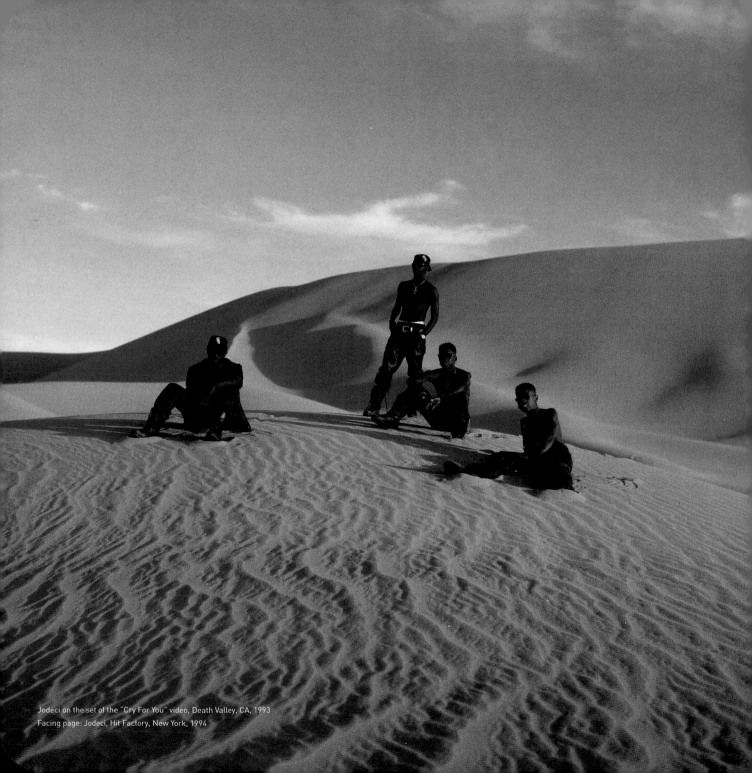

Jodeci on the set of the "Cry For You" video, Death Valley, CA, 1993
Facing page: Jodeci, Hit Factory, New York, 1994

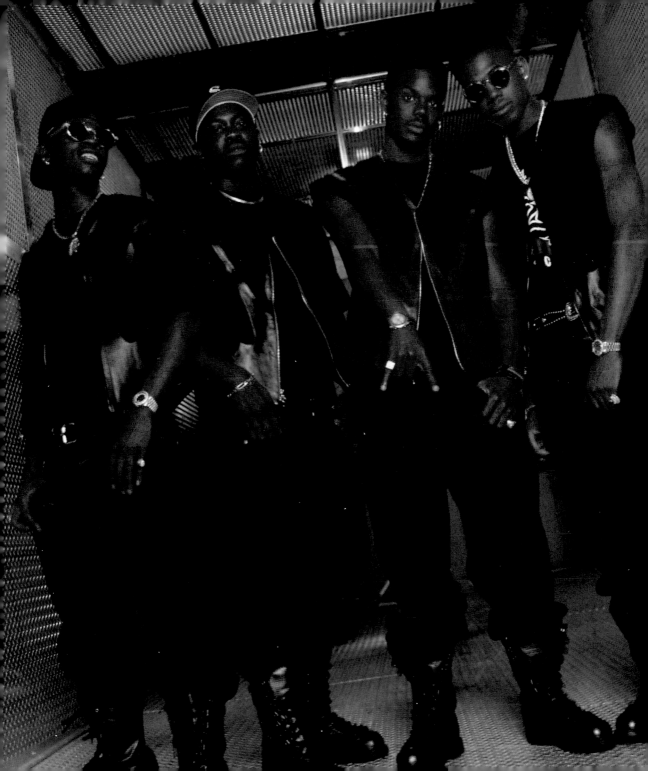

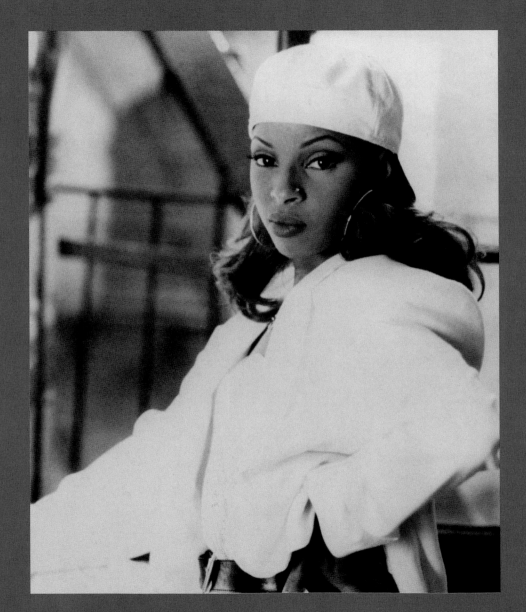

Mary J. Blige on the set of the
"What's the 411?" video, Tribeca,
New York, 1992

Facing page: Mary J. Blige,
New York, 1994.

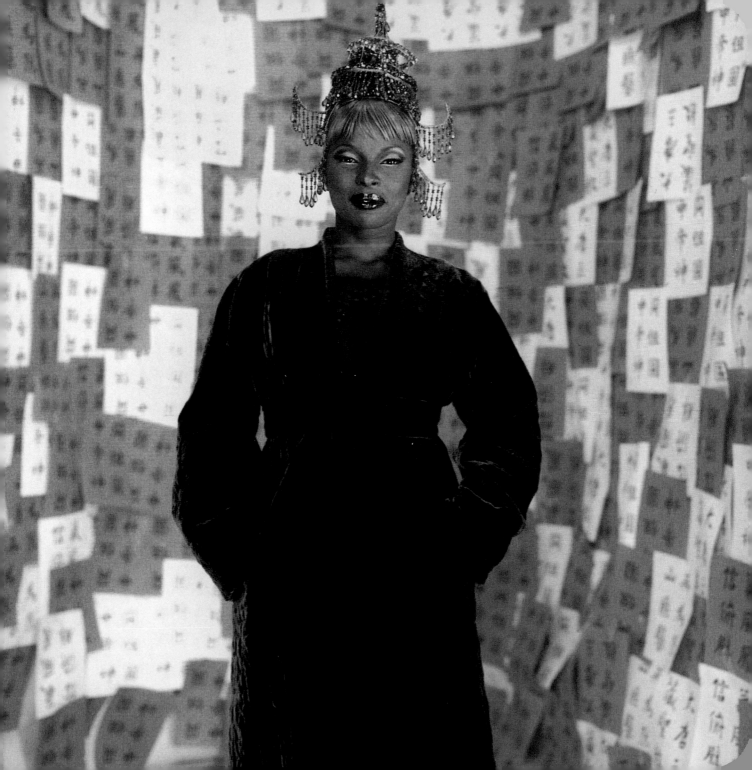

BOY

Bad Boy was established in 1993 by Sean "Puff Daddy" Combs, then 23 years old, following his unceremonious firing from Andre Harrell's Uptown label. He was put back into the record business by Clive Davis, who is, like Puff, legendarily headstrong and who founded the Arista label years earlier after he himself had been fired from Columbia Records.

Puff brought two artists with him from Uptown: Craig Mack and Biggie Smalls. Mack got into the business as a roadie for EPMD and launched his career as the rapper MC EZ in 1988. In 1994, under his own name, Mack became Bad Boy's first artist, launching the label with the monster hit single, "Flava In Ya Ear."

Biggie, a/k/a The Notorious B.I.G., turned out to be Puffy's greatest discovery. With Puffy as his executive producer, Biggie seemed to emerge fully formed, a writer and rapper of great and caustic wit who crowned himself King of New York and effortlesly embodied the suave gangster persona of his own first-person narratives. Born Christopher Wallace and raised in Brooklyn's Bed-Stuy neighborhood, Biggie almost single-handedly helped to restore New York's hip-hop reputation after several years during which rappers from Los Angeles, notably NWA, Dr. Dre, and Snoop Dogg, seemed to set the tone for the culture.

Many of the other artists on Bad Boy's roster were pro- tégées of Biggie. Total's first gig was singing the chorus on "Juicy," Biggie's first Bad Boy single. The singer Faith Evans met Biggie at a Bad Boy photo shoot, and the two got married ten days later. Faith made her feature debut on Biggie's "One More Chance (Remix)" and gave birth to Biggie's son, Christopher Jr., late in 1996. The rapper Lil Kim, like Biggie, was a product of Bed-Stuy. She made her debut as a member of Biggie's Junior M.A.F.I.A.

late in 1994. The rapper Charli Baltimore—who named herself after a beautiful and deadly CIA agent played by Geena Davis in *The Long Kiss Goodnight*—debuted in Junior M.A.F.I.A.'s "Get Money" video in 1996. Although Mase was brought into the fold by Puffy, one of his earli- est high-profile guest appearances was on Biggie's "Mo' Money, Mo Problems." As a recording artist, even Puffy was a protégé of Biggie, who had volunteered to produce tracks for Puff's debut album.

But Biggie was shot and killed in March of 1997, presum- ably as payback for the murder half a year earlier of Tupac Shakur. (The two were friends until Tupac decided that Biggie was somehow responsible for an attack on him in New York, 1995.) Puff turned his debut album, *No Way Out*, into a multiplatinum tribute to Biggie.

Shyne, born Jamal Barrow in Belize and raised in Brooklyn, was a promising rapper signed to Bad Boy after Biggie died. His career was derailed when he fired a gun in a New York nightclub in December of 1999, reportedly in an attempt to protect Puffy, who had been assaulted by another patron. He was convicted of first-degree as- sault, gun possession, and reckless endangerment, and sentenced to ten years in jail, where he remains.

BOY

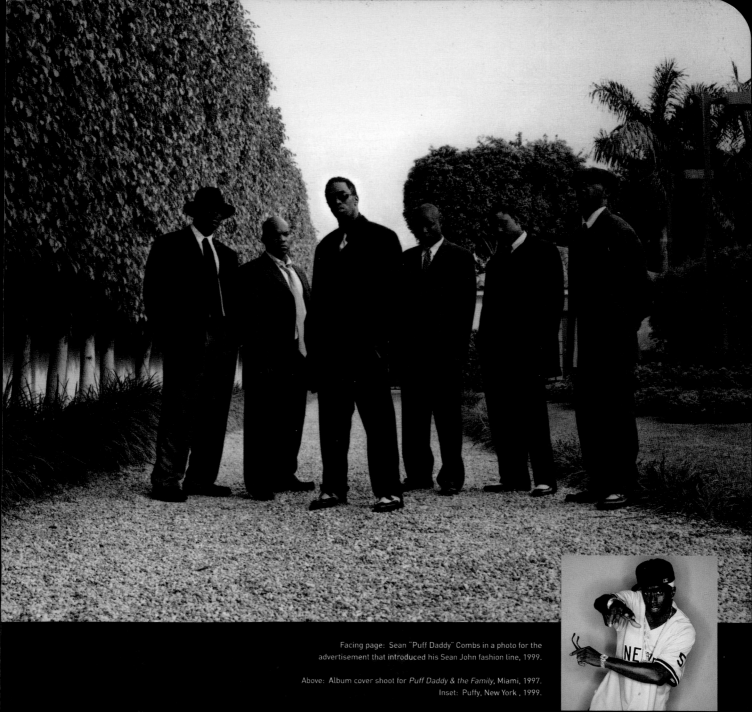

Facing page: Sean "Puff Daddy" Combs in a photo for the advertisement that introduced his Sean John fashion line, 1999.

Above: Album cover shoot for *Puff Daddy & the Family*, Miami, 1997.
Inset: Puffy, New York , 1999.

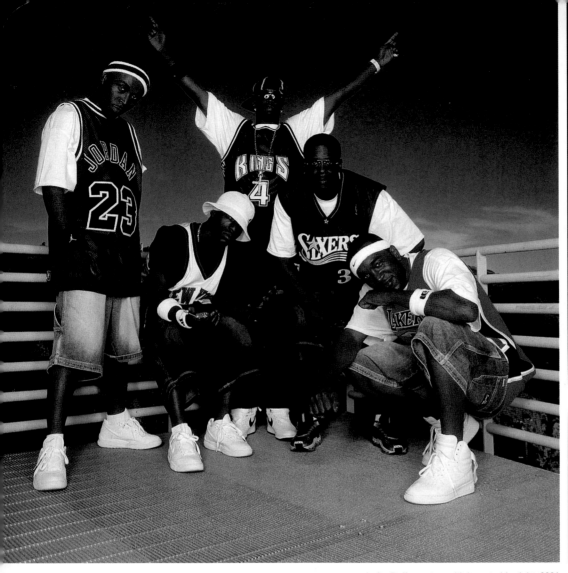

Left: Puffy, center, with Loon to his right, 2001
Center: Puffy, New York, 2000
Right: Mase, New York, 2000
Below right: Puffy and Mase, New York, 1999

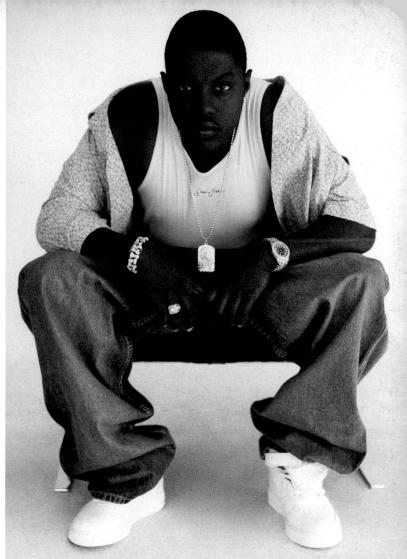

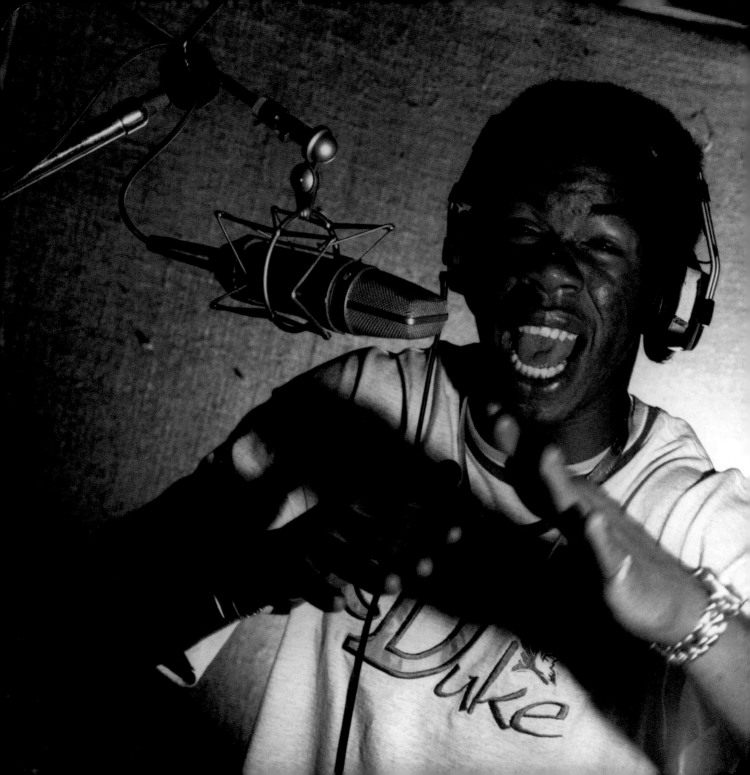

Facing page: Craig Mack cutting "Flava in Ya Ear,"
Daddy's House, New York, 1993.
Above: Shyne, 5th Ave, New York, 1999.
Right: Shyne posing for a Sean Jean advertisement.

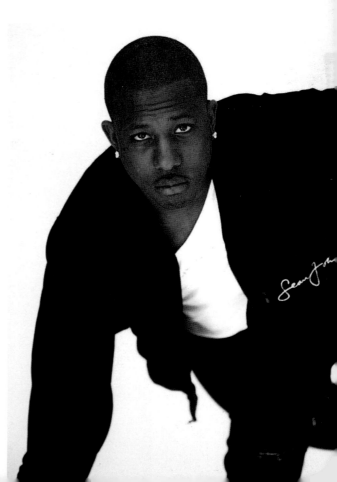

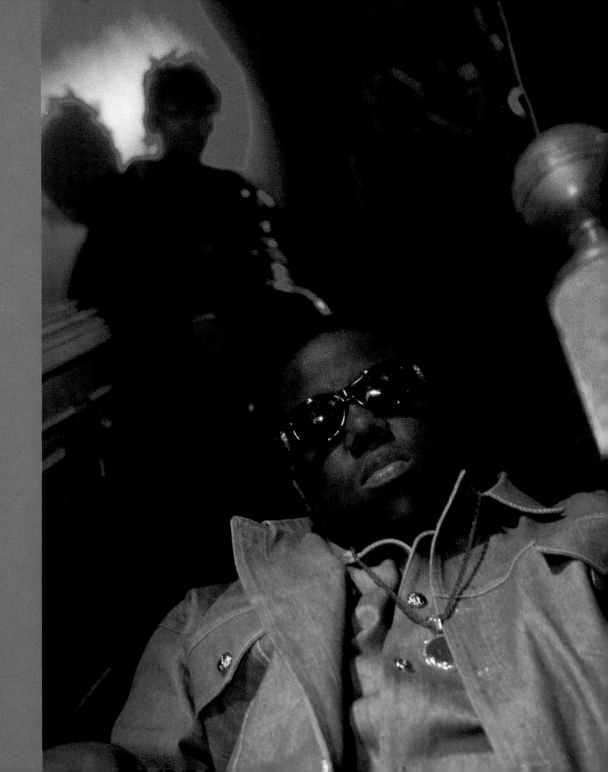

Facing page: Biggie Smalls on the set of the "One More Chance (The Remix)" video, New York, 1995.

Above, left to right: Charli Baltimore, 1998, Faith Evans on the set of the "Soon As I Get Home" video, 1996, and Lil Kim, New York, 1996.

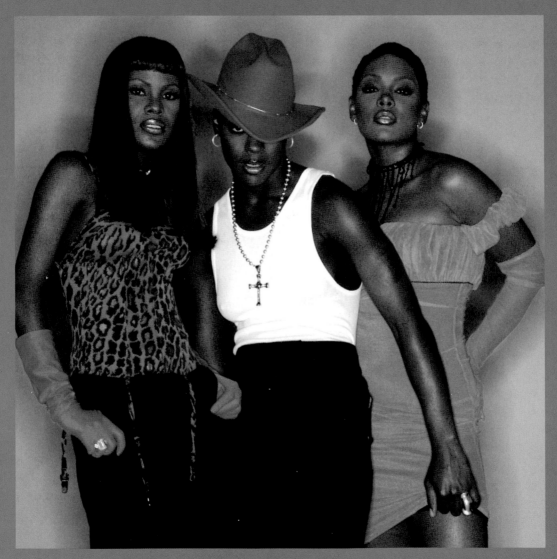

Total, New York, 1996
112, Tribeca, New York, 1996

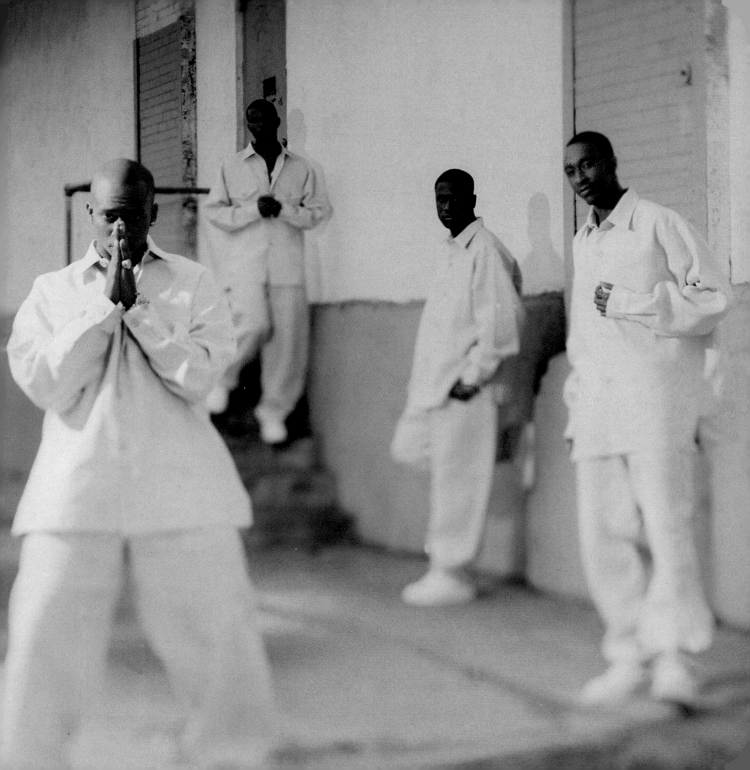

Jive Records was founded in England in 1975 by the indie-minded South African music mogul Clive Calder. In 1981, Calder set up an office in New York and chose Barry Weiss to run it for him. A second-generation indie record businessman, Barry is the son of Hy Weiss, who owned the R&B-oriented Old Town label in the Fifties and Sixties.

During the Eighties, Jive assembled a roster of rap acts that included pop-friendly acts like Brooklyn's Whodini and Philly's Jazzy Jeff & the Fresh Prince, and, hood oriented acts like the Bronx's Boogie Down Productions and Oakland's Too Short. At the start of the Nineties, Jive signed up A Tribe Called Quest, the last to emerge of the playful, jazzy, boho-oriented Native Tongues Posse, whose members also included De La Soul and the Jungle Brothers. All of Jive's performers benefited from the label's determined sales and marketing efforts, including an early appreciation of the value of good-looking music videos.

Although Jive has continued to release creditable rap by such artists as E-40, Spice 1, and Petey Pablo, the label has been better known since the late Nineties for superstar teen pop by the likes of the Backstreet Boys, N'Sync, and Britney Spears.

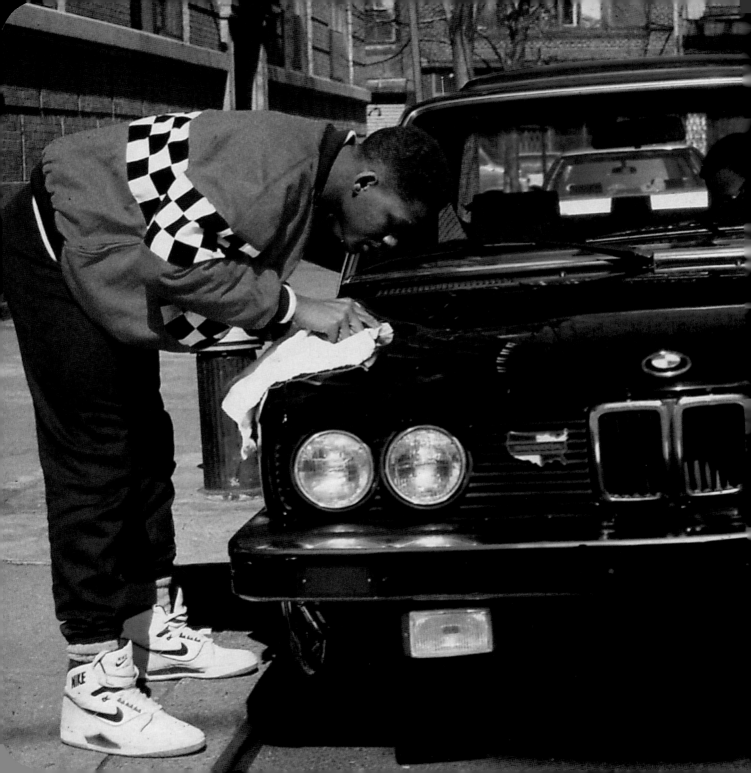

Facing page: The Fresh Prince & Jazzy Jeff,
Elizabeth Street, New York, 1988

Below and bottom: Jazzy Jeff and "The Fresh Prince"
Will Smith on the set of the "Summertime" video, 1991

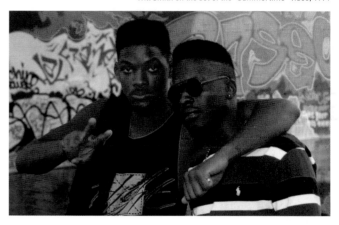

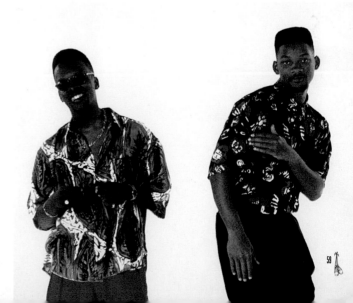

59

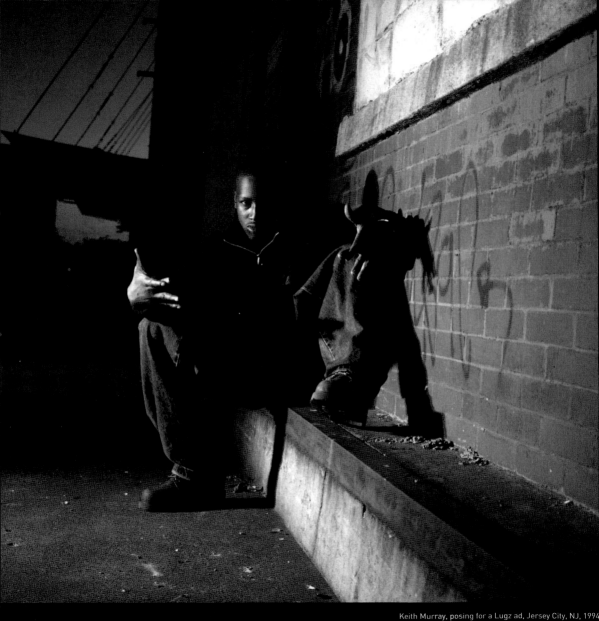

Keith Murray, posing for a Lugz ad, Jersey City, NJ, 1994

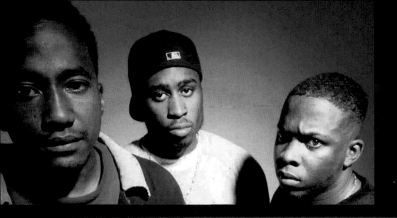
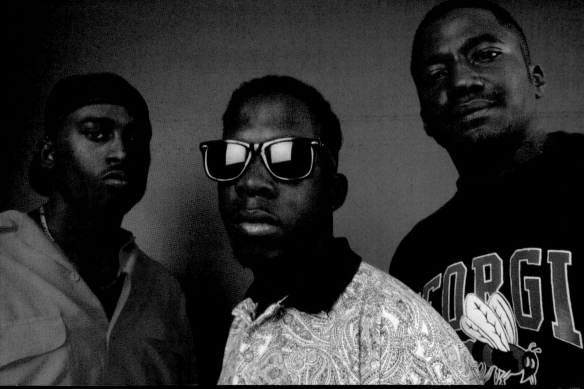

Top: A Tribe Called Quest Q-Tip, Ali Shaheed Muhammad, and Phife New York, 1990.

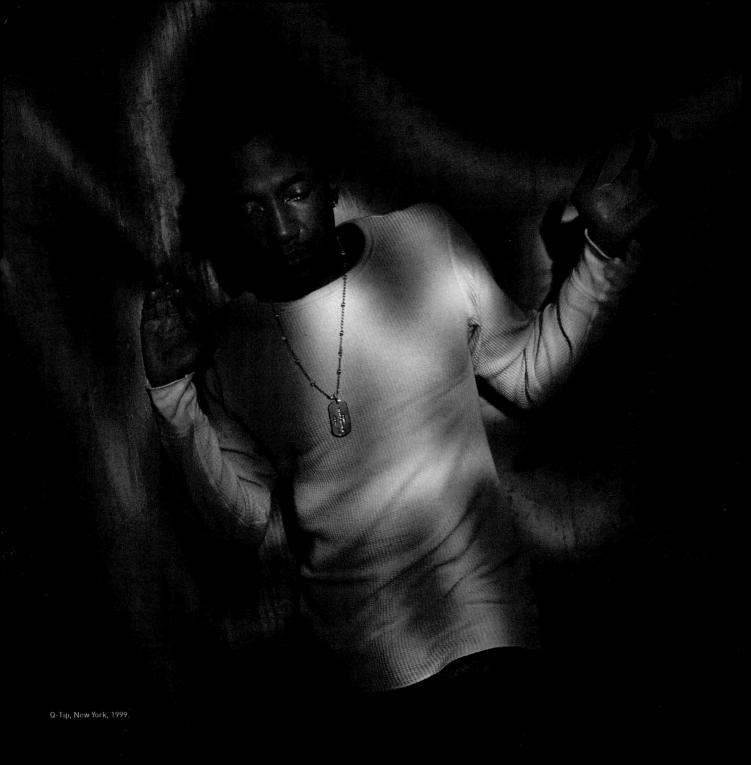

Q-Tip, New York, 1999.

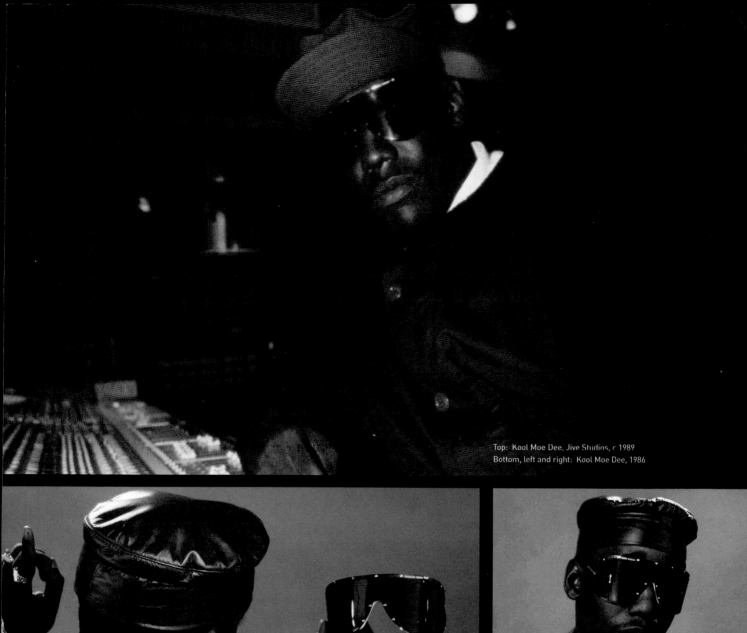

Top: Kool Moe Dee, Jive Studios, c 1989
Bottom, left and right: Kool Moe Dee, 1986

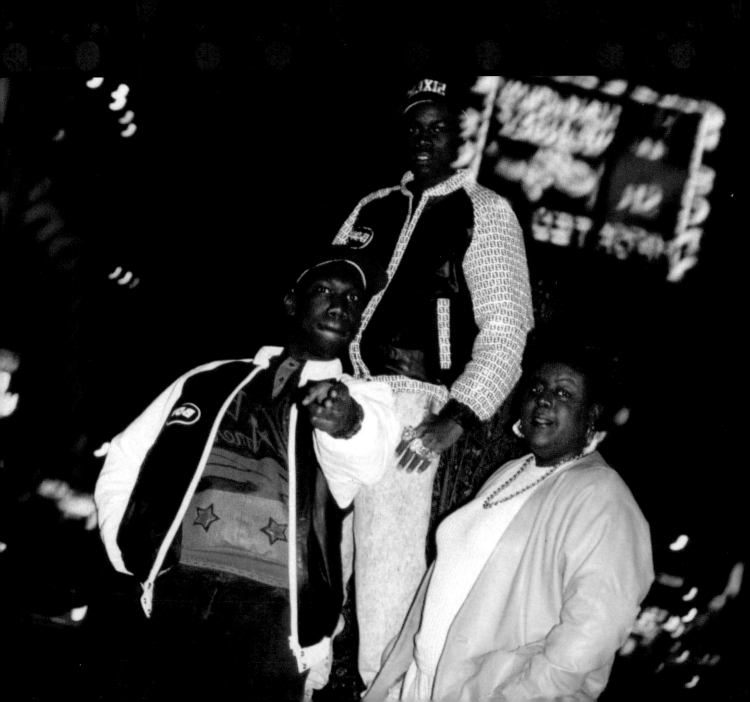

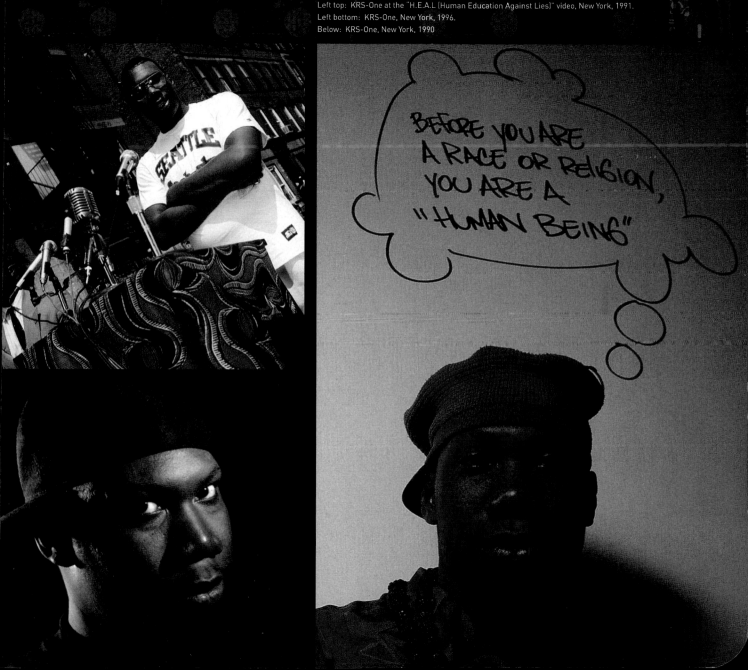

Too Short, New York, 1992

Facing page: Too Short on Hollywood Blvd.,
outside the L.A. offices of Jive Records, CA,1992.

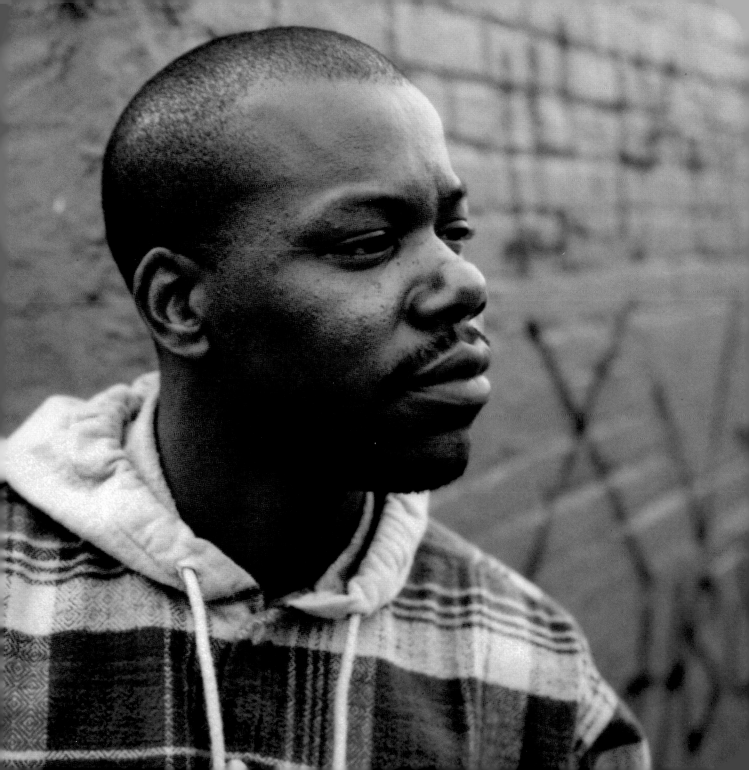

CHILLIN'

The Cold Chillin' label grew out of, ambitions of the Juice Crew. In the beginning, the crew was comprised of pioneering hip-hop radio announcer Mr. Magic (a/k/a Sir Juice), his producer Fly Ty Williams, and his deejay Marley Marl. Magic and Ty were from Brooklyn. Marley was from Queens.

The trio were all working on Magic's "Rap Attack" at New York's WBLS when UTFO released "Roxanne, Roxanne" in 1985. Marley produced an answer record entitled "Roxanne's Revenge" by a sassy little 14-year-old girl who called herself Roxanne Shante and who lived, like Marley, in the Queensbridge Housing Project. A year later, Marley cut a track with his cousin MC Shan (also a resident of Queensbridge) called "The Bridge." An ode to their housing project, the record inspired a blistering answer record from Boogie Down Productions called "South Bronx."

At around the same time, Marley started making demos with the comical Mr. Biz Markie, who he'd discovered beatboxing in the hallways at, that's right, Queensbridge. He also produced "It's a Demo," featuring Kool G Rap and DJ Polo. G Rap, out of Corona, Queens, was a pioneering gangsta storyteller whose "Road to the Riches" and "Streets of New York" would establish themselves as Cold Chillin' landmarks a few years later.

Ty got Biz a record deal with Lenny Fichtelberg's Prism Records. As the manager of Magic, Marley, Shante, Shan, and Biz Mark, Ty quickly persuaded Len to partner up with him in a new label to be called Cold Chillin'. Marley, of course, was the label's house producer; his ear for funky samples and ability to shape a dynamic arrangement were crucial to the success of all of the Cold Chillin' artists. (Not to mention such non–Cold Chillin' artists as LL Cool J, whose career Marley revived as the producer of *Mama Said Knock You Out* in 1990.)

In 1987, Cold Chillin' struck a distribution deal with Warner Bros. One of their first albums was by Big Daddy Kane, a Brooklynite who'd been brought into the crew by Biz and cut his teeth writing rhymes for Roxanne Shante and for Biz himself. Cold Chillin' had a great run for the next five years, during which time it helped to define what is often referred to as Hip-Hop's Golden Age.

CHILLIN'

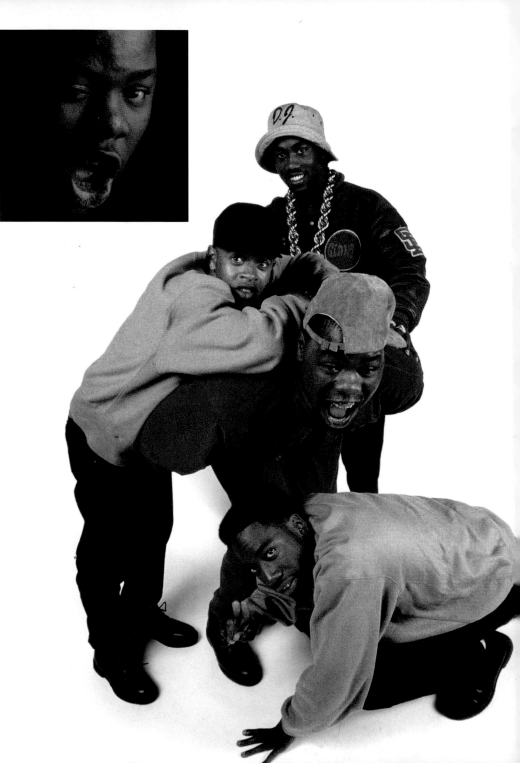

Biz Markie, New York, 1989
Right: Biz Markie, and his crew New York, 1989

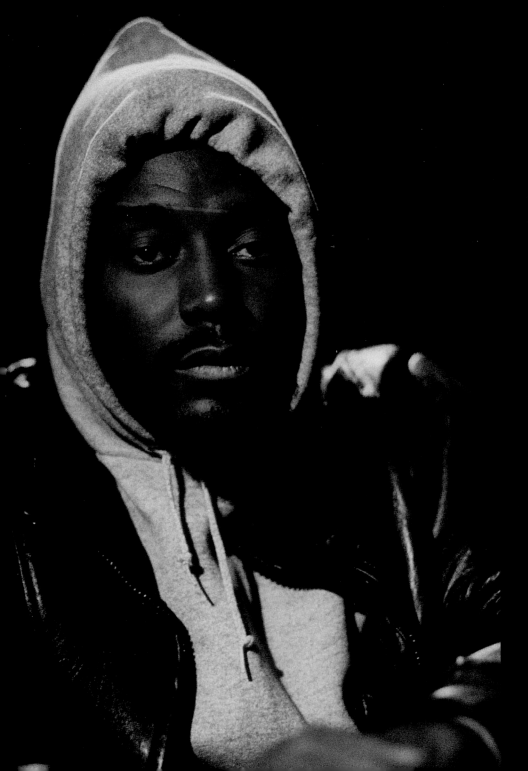

Inset top: Big Daddy Kane, New York, 1991
Inset bottom: Big Daddy Kane, 1989

Left: Big Daddy Kane, New York City, 1991

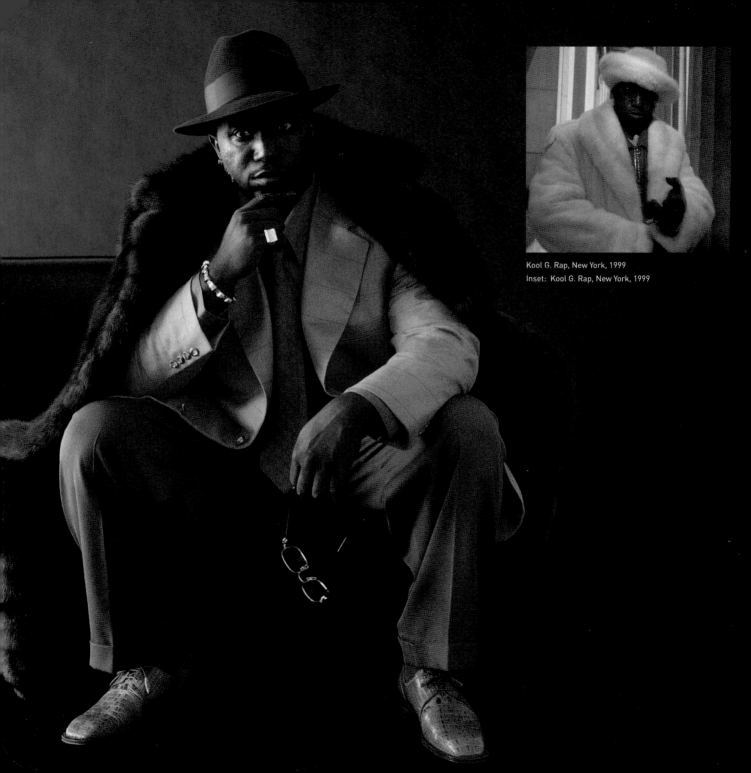

Kool G. Rap, New York, 1999
Inset: Kool G. Rap, New York, 1999

Above: MC Shan

Left: Marley Marl , at his house in New Jersey 1996

BOY

Tommy Boy Records was founded in 1981 by Tom Silverman, a music lover from White Plains, New York. Tom was publishing a biweekly tipsheet called *Dance Music Report* in 1980, when he struck up a friendship with hip-hop godfather Afrika Bambaataa. In 1982, Tommy Boy released "Planet Rock" by Bam and the Soul Sonic Force. It quickly lived up to its name, becoming a huge international smash, and putting Tommy Boy on the rap map.

Tom's first full-time employee, a Chicagoan named Monica Lynch, was hired as an intern to work on "Planet Rock." By 1985, she'd become the label's president. From that point on, Tom, the label's CEO, concentrated on marketing, while Monica concentrated on talent acquisition and artist development. The label went into business with Warner Bros. Records in 1985, although it continued to maintain a strong independent distribution system of its own.

Tommy Boy signed Brooklyn's Stetsasonic in 1986. Prince Paul, one of Stet's two deejays, brought De La Soul to Tommy Boy in 1988. A year later, *Yo! MTV Raps's* Fab 5 Freddy brought Newark's Queen Latifah, then 18, to Tommy Boy. Latifah's Flavor Unit Management brought fellow New Jerseyans Naughty By Nature to Tommy Boy shortly afterward. San Francisco's Digital Undergound started to make funky hits for Tommy Boy in 1989. L.A.'s House of Pain, Irish-American protégés of Ice-T, hit with "Jump Around" in 1992, while Compton's Coolio signed to TB in 1994 and dropped "Gangsta's Paradise," a mega-hit, the following year.

Tommy Boy and Warner Bros. parted ways in 2002. Tommy Boy Entertainment is once again a fully independent label.

Left: De La Soul, New York, 1989. Left to right: Dove, Mase, and Pos.
Below: De La Soul on 5th Avenue, New York, 1989. Left to right: Dove, Mase, and Pos.

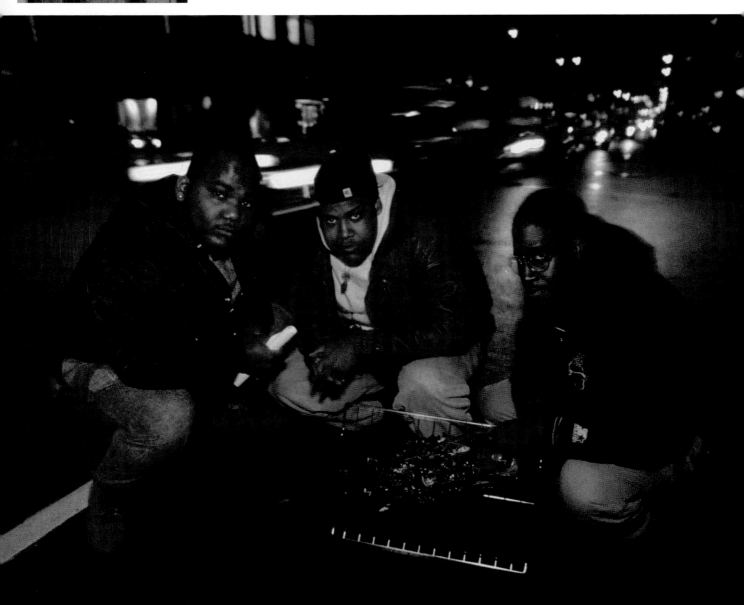

Naughty By Nature outside of the offices of Flavor Unit Entertainment, Jersey City, NJ, 1991. Left to right: Vinnie, Treach, and Kay Gee.

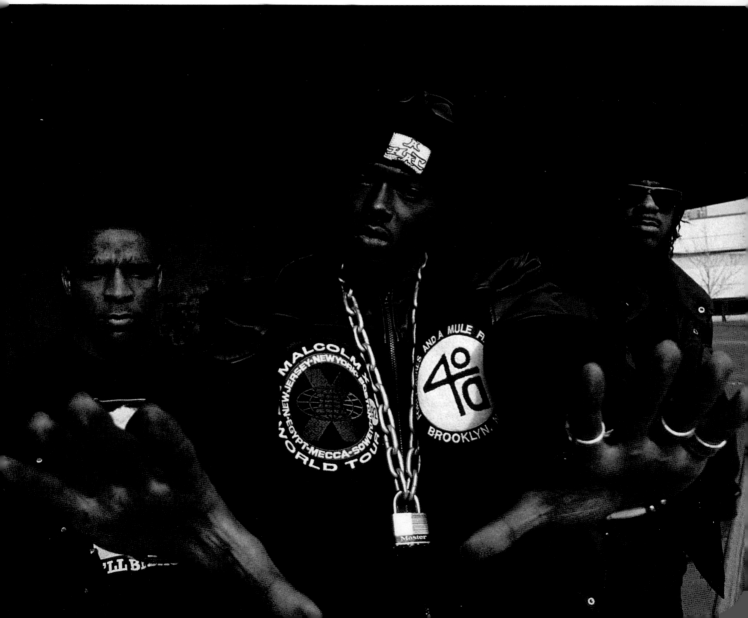

Above: House of Pain, Harlem, New York, 1993.
Facing page: House of Pain, (left to right)—Everlast, Danny Boy, DJ Lethal.

RUFF

Ruffhouse Records was founded by Chris Schwartz and Joe Nicolo, a pair of Pennsylvanians who made a virtue out not being based in New York. Schwartz cut his teeth managing Philly's Schooly D and developing the art of street promotion. Nicolo engineered records for Philly's Jazzy Jeff & the Fresh Prince and such esteemed visitors as Salt'N'Pepa and Biz Markie. The pair went into business with Enigma Records in 1986, then hooked up with Columbia in 1989.

Extremely artist oriented, Ruffhouse enjoyed a lot of success with a small roster. "Our mission was to try to expand the horizons for rap to a non-hardcore audience who might say, 'I don't listen to rap, but I like this,'" said Nicolo. Their first smash was with L.A.'s pot-loving Cypress Hill, who enjoyed favor with both hardcore hip-hoppers and alternative rockers. The next year, Ruffhouse got behind 19-year-old Jermaine Dupri, who produced a winning album for a couple of 12-year-old mall rats who wore their pants backward and called themselves Kriss Kross. The label released the Fugees debut album in 1994 and then enjoyed unprecedented success when they put out The Fugees's *The Score* in 1996, which sold 17 million copies behind the allure of Lauryn Hill's performance of "Killing Me Softly." Two years later, *The Miseducation of Lauryn Hill* was a best-selling landmark of intelligent, versatile, and sexy hip-hop.

In March of 1999, Ruffhouse celebrated their tenth birthday. A month later, the partners dissolved the label. Nicolo was tired of playing second banana to the more media-friendly Mr. Schwartz.

The Fugees—Wyclef Jean, Pras, Lauryn Hill—New York, 1994.

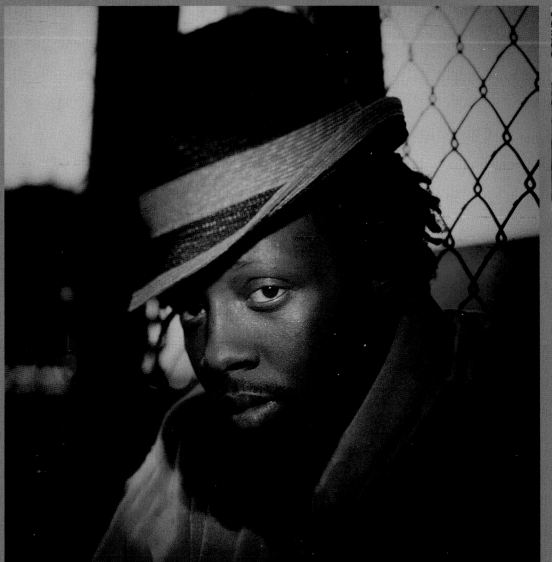

Above: Canibus, 1998

Left: Wyclef Jean, Tribeca, New York, 1997

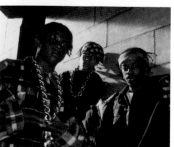

Facing page: Cypress Hill—DJ Muggs, Sen Dog, and B-Real—New York, 1991.
Top: Kriss Kross—Chris Smith and Chris Kelly—New York, 1992
Bottom: Kriss Kross with Jermaine Dupri on the set of
Run-DMC's "Down with the King" video, Harlem, New York 1993.

RUTHLESS

Ruthless Records was formed by Compton, California's Eric "Eazy E" Wright in 1985, allegedly with money he'd made as a drug dealer. Present at the creation was Andre "Dr. Dre" Young, a talented deejay-turned-producer who was also from Compton. The label's first album, released in 1987, was *NWA and the Posse*. It was followed a year later by *Straight Outta Compton*, one of the early landmarks of "gangsta rap." Although NWA's lead voice was Ice Cube, their secret ingredient was the Dallas-born rapper who called himself The D.O.C. and wrote rhymes for Eazy, Dr. Dre, and MC Ren. In turn, Dre produced The D.O.C's debut Ruthless album *No One Can Do It Better* in 1989.

Ice Cube left NWA and Ruthless in 1990. Dre and The D.O.C. left a year later. All of them claimed to have been ripped by their old friend Eazy, who'd brought in a veteran music businessman named Jerry Heller to help him run the label. Eazy and Ruthless con-

success story in rap in the early Nineties—had filed for bankruptcy.

But by then, Dre and Suge had fallen out. Early in 1996, Dre left Death Row and formed a new label called Aftermath. Tupac was shot and killed in September of 1996, and Suge was sent to prison for violation of parole, which meant curtains for Death Row. Ruthless had gone belly up not long after the death of Eazy E from AIDS in March of 1995.

Cube and Snoop continue to record for other labels. Dre's Aftermath, in partnership with Interscope Records, has given the world Eminem and 50 Cent.

RUTHLESS

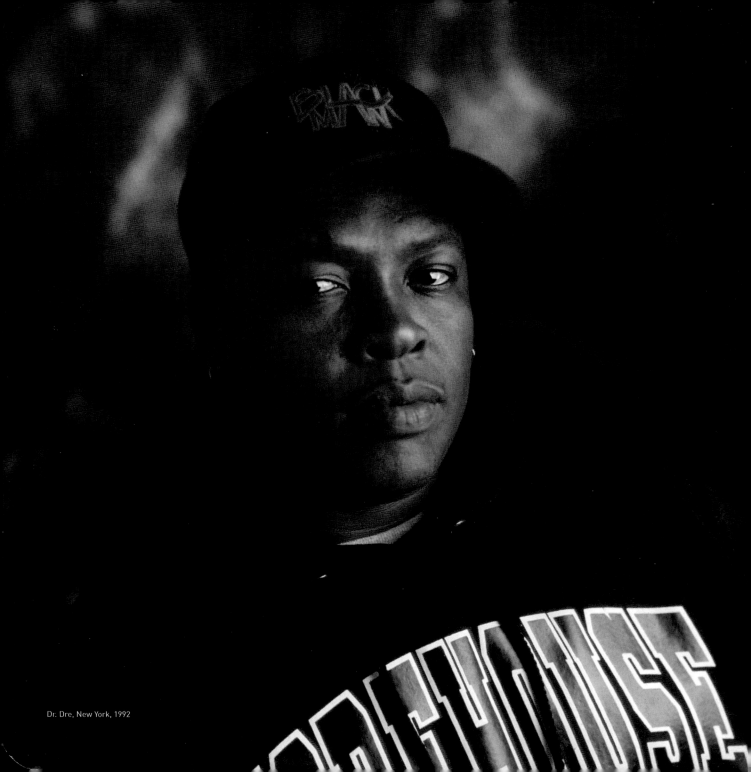

Dr. Dre, New York, 1992

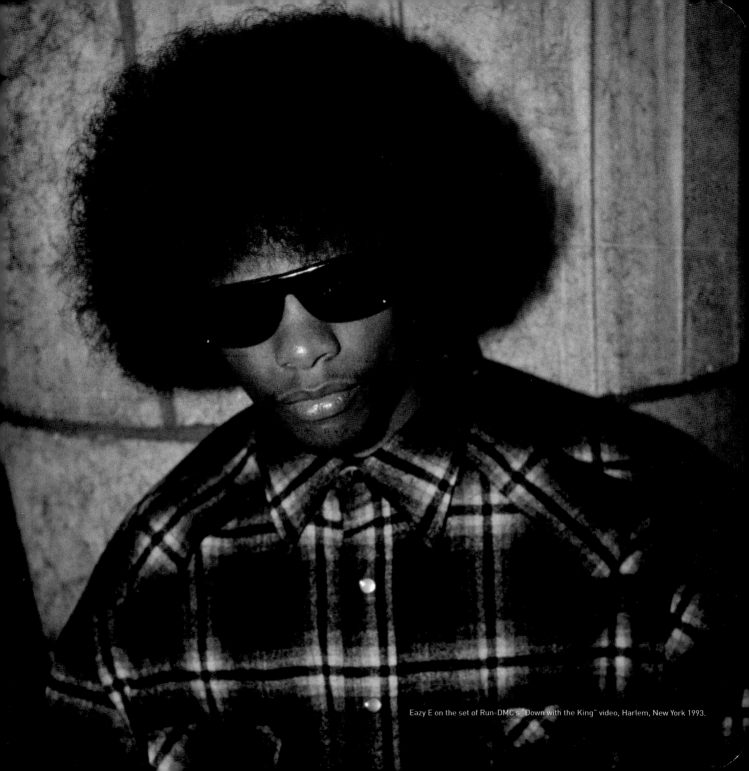

Eazy E on the set of Run-DMC's "Down with the King" video, Harlem, New York 1993.

The D.O.C., New York, 1989

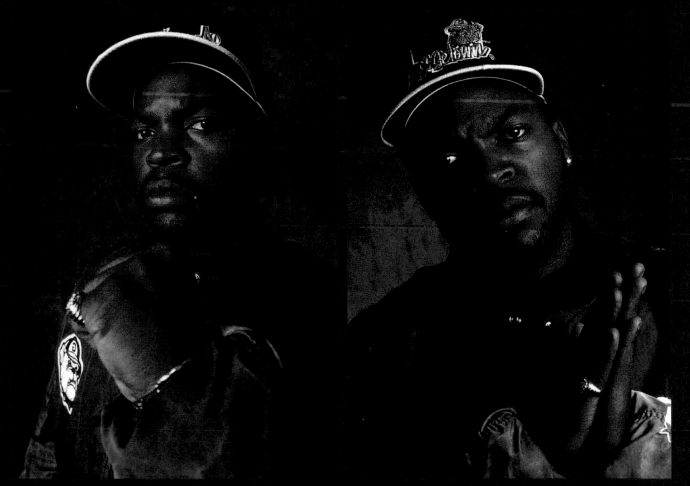

Ice Cube, New York, 1990

Snoop Dogg, New York, 1992

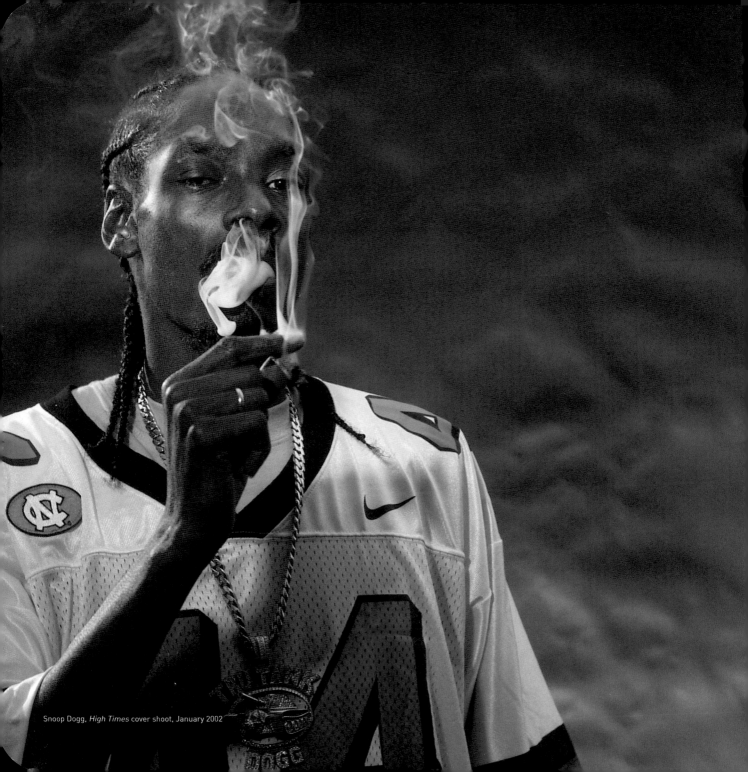

Snoop Dogg, *High Times* cover shoot, January 2002

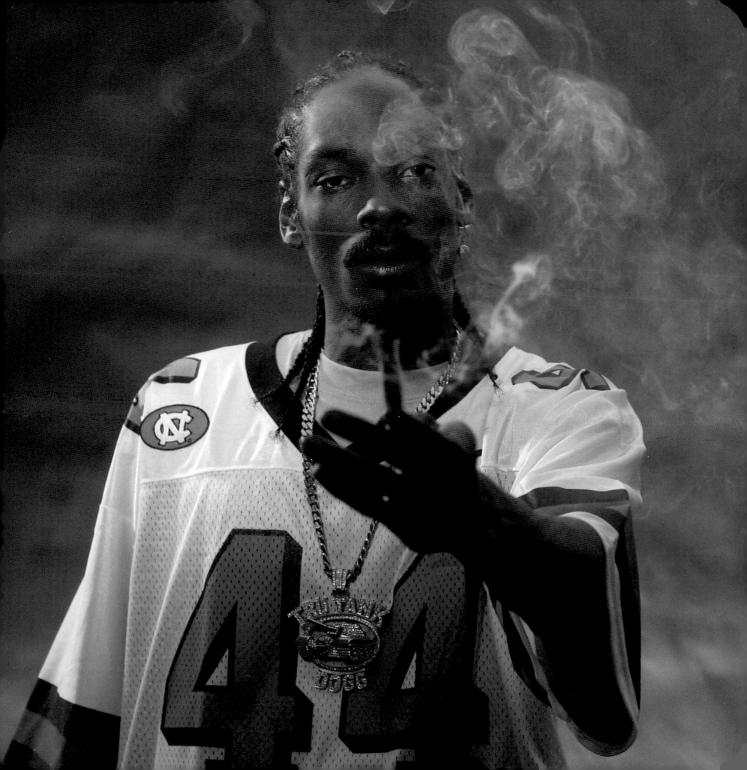

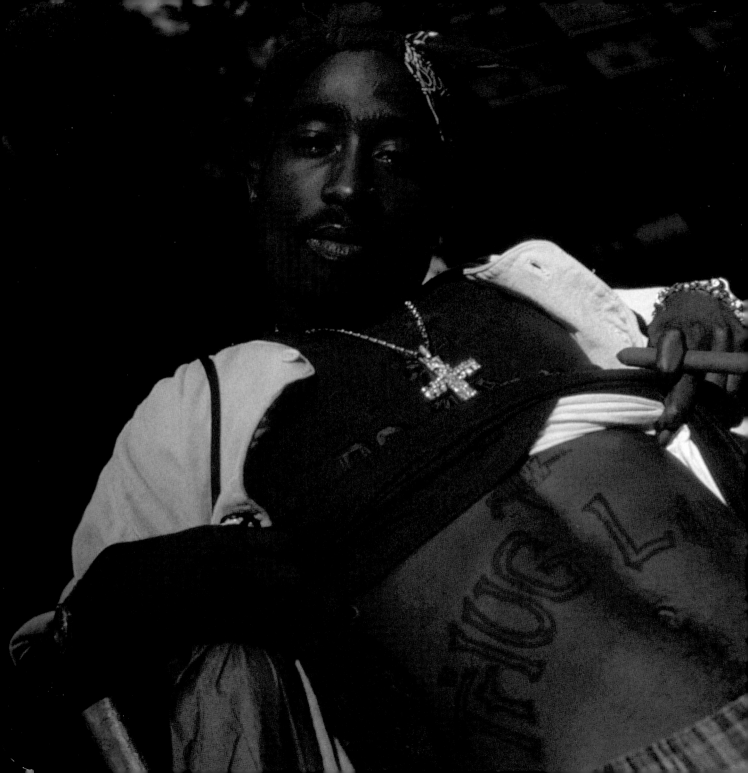

Facing page: Tupac Shakur, Harlem, New York 1994
Above: Suge Knight, New York, 1992

LADIES

There are times when the world of rap seems about as open to female participation as the Little Rascals' He-Man Women Haters Club. No less an authority than Chuck D has argued that women are interlopers in an idiom created by and for black men . . . and besides, women already own R&B.

Despite this hostility, there have been important women in the game since the very beginning. Some of them have been as "gangsta" as any of the guys. Some have been sweet. Some have been sexy. But all of them have demanded to be heard. The debut singles by the Real Roxanne and Salt'N'Pepa were tart answer records to tracks cut by UTFO and Slick Rick, respectively. The top-notch writing and rapping skills of MC Lyte, as demonstrated by her first single, "I Cram to Understand You (Sam)" won her universal respect. Queen Latifah debuted with "Ladies First," a straight-up feminist anthem, trading verses with Monie Love. Yo-Yo made her debut snapping on Ice Cube on a track called "It's a Man's World." Trina's signature track, "Da Baddest Bitch," was a tough little gem of sexual self-determination.

Indeed, Chuck D notwithstanding, rap and R&B have moved closer together in recent years, which helps to account for the affection many hip-hoppers felt for TLC and Aaliyah. After all, as Ja Rule has pointed out, every thug needs a lady.

The Real Roxanne, New York, 1988

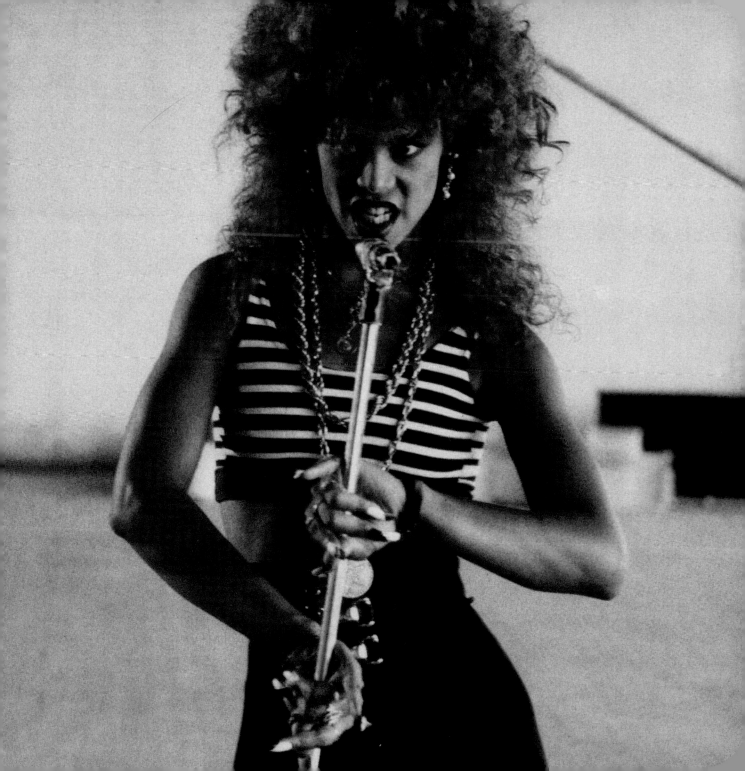

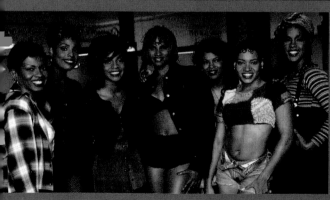

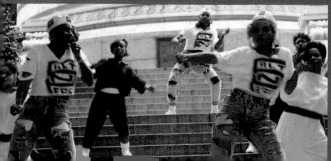

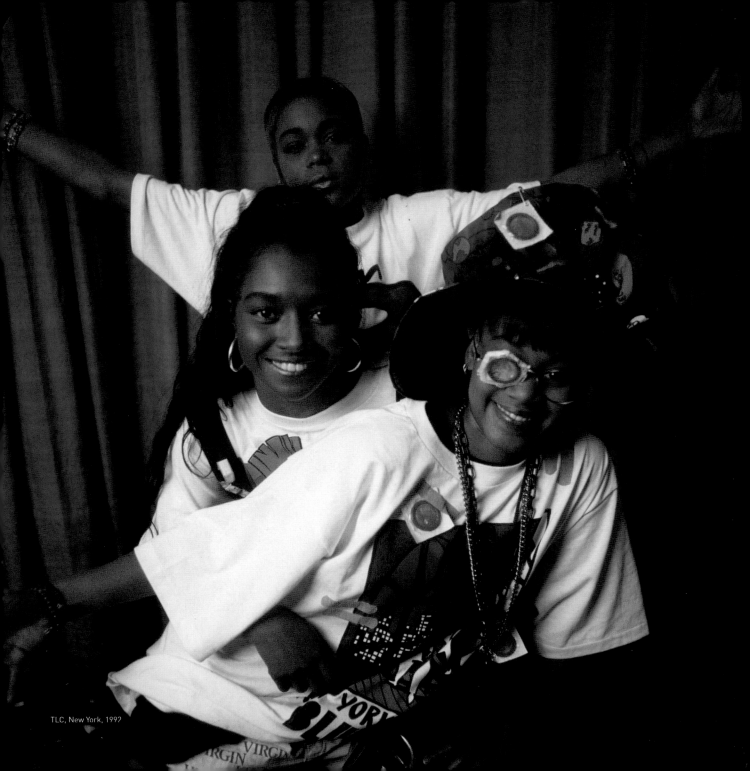

TLC, New York, 1992

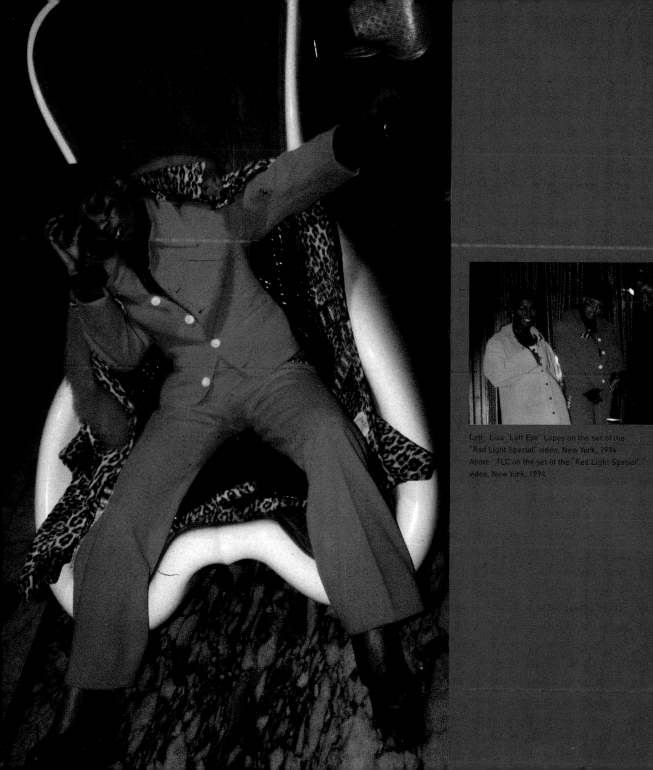

Left: Lisa "Left Eye" Lopes on the set of the
"Red Light Special" video, New York, 1994
Above: TLC on the set of the "Red Light Special"
video, New York, 1994

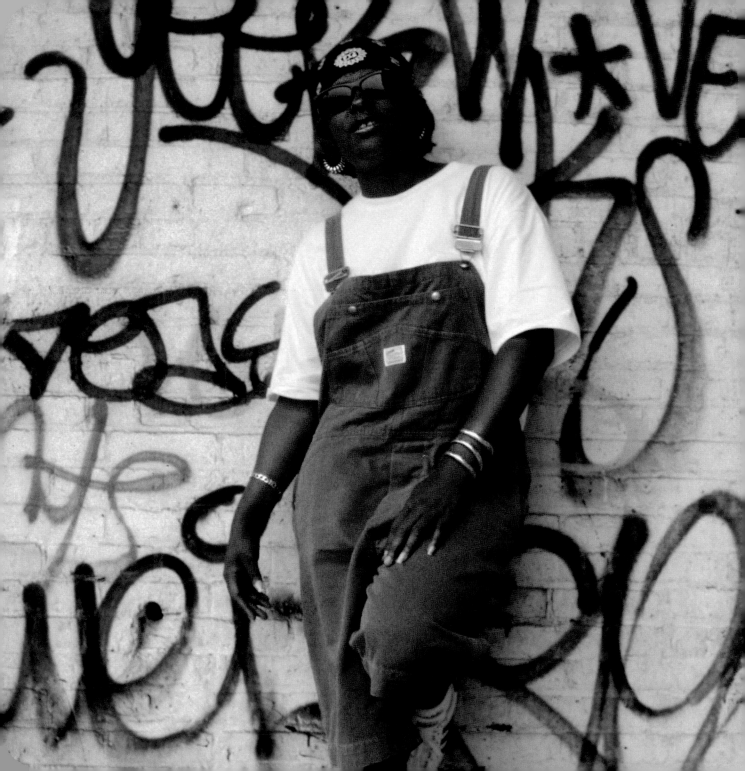

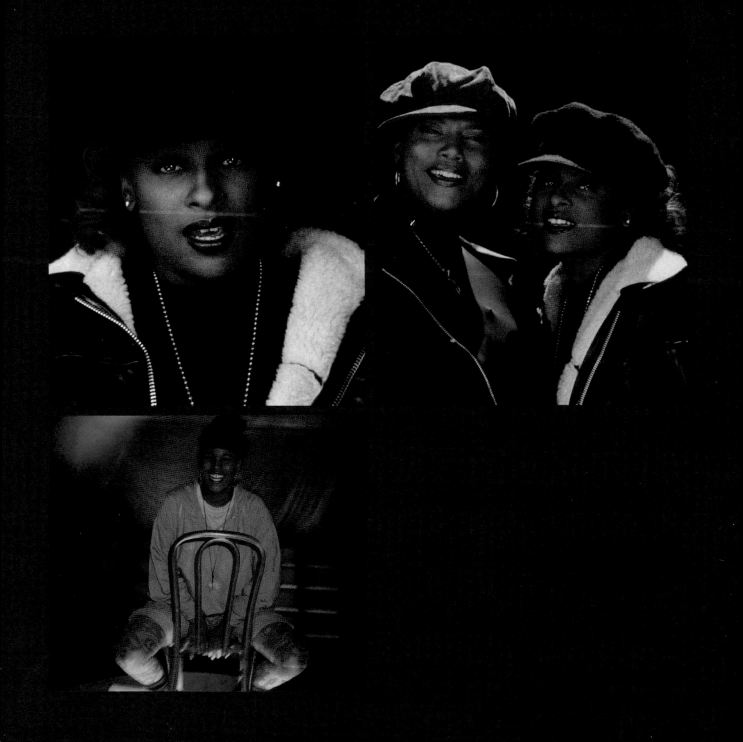

Aaliyah, New York, 1994

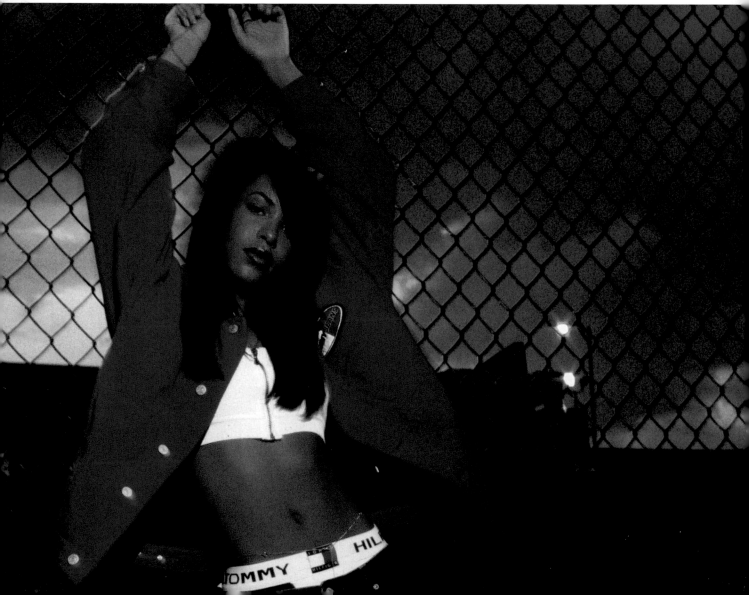

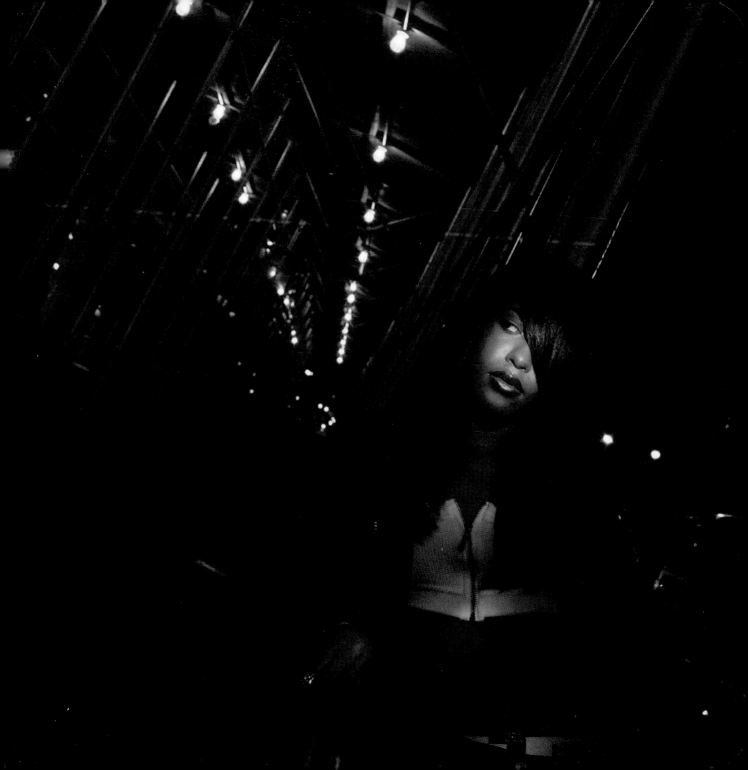

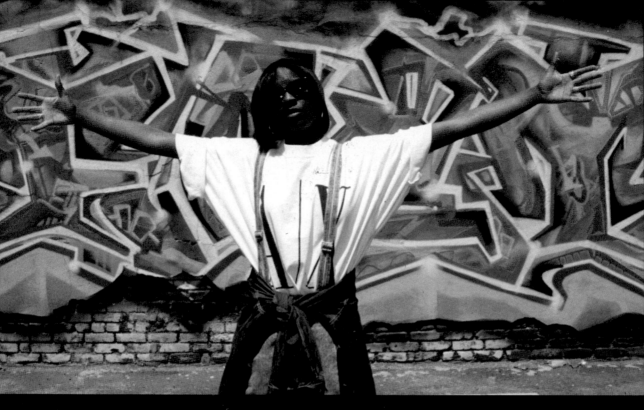

Top: MC Lyte
Bottom: MC Lyte, New York, 1993.
Facing page: Trina on the set of the video for
"Da Baddest Bitch," Miami, 2000.

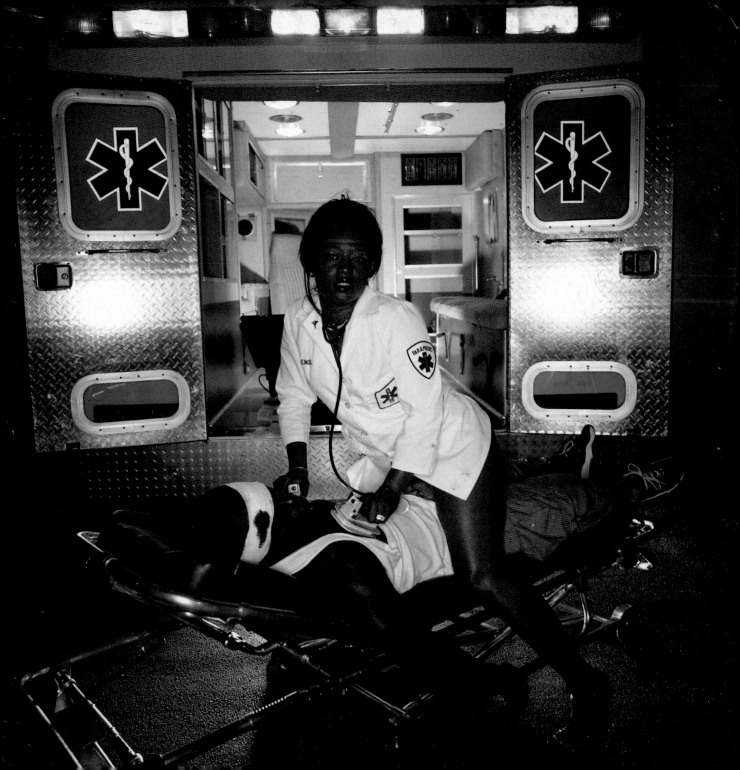

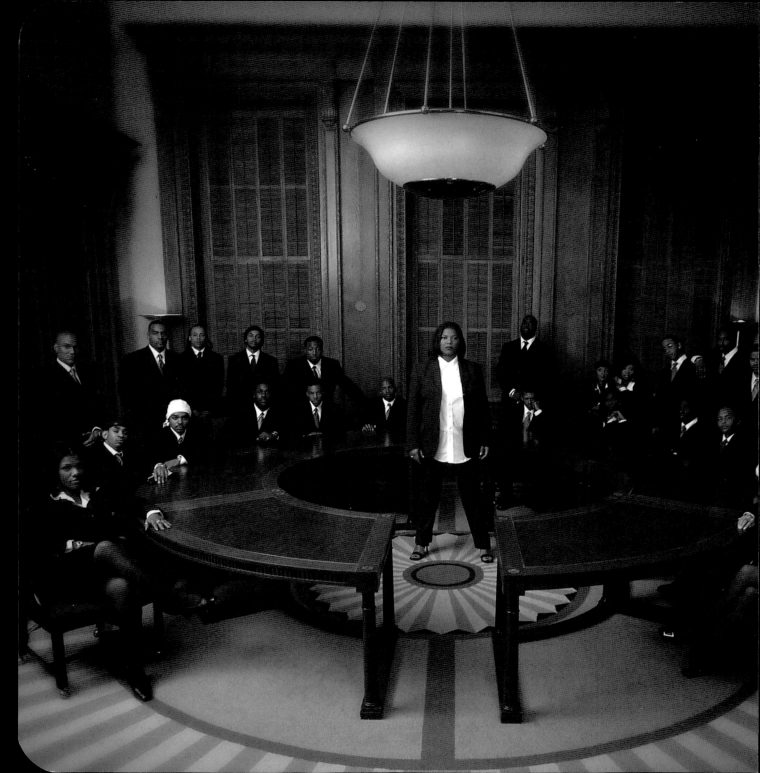

Above: Queen Latifah
Facing page: Queen Latifah and the Flavor Unit,
album cover shoot for *The Takover*, New York, 2000.

DJ'S VS. PRODUCERS

In the beginning, the deejay was king, with the rapper no more than a hype man charged with praising the party master behind the turntables. In terms of glamour, that little status hierarchy flipped with the release of the first rap records. Suddenly, the rapper was the star, and the deejay at best, a one-man band.

But many great deejays quickly morphed into record producers. And, indeed, it is the hip-hop deejay's sensibility—the reverence for earlier recordings balanced by a readiness to transform those recordings in an infinite number of ways—that undergirds the production of rap records to this day. In short, the deejay/producer is damn near as cool as he ever was, leaving young hip-hoppers just as likely to dream of growing up to be like Dre as they would of Snoop.

Michael, who spent many a day and night in the recording studio, shot the person behind the board with the same seriousness and regularity as he did the person on the mic.

DJ'S PRODUCERS

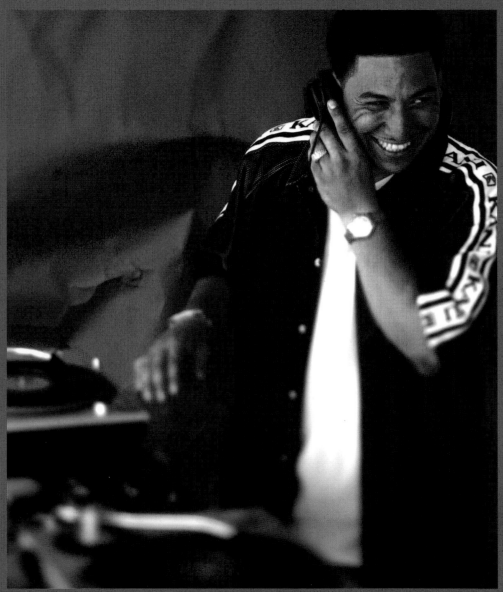

DJ Kid Capri, New York, 2000

Chuck Chillout, New York, 1990 Miles Davis and Easy Mo B, New York, 1992

Above: Guru, New York, 1990 Below: DJ Premier and Guru, New York, 1991

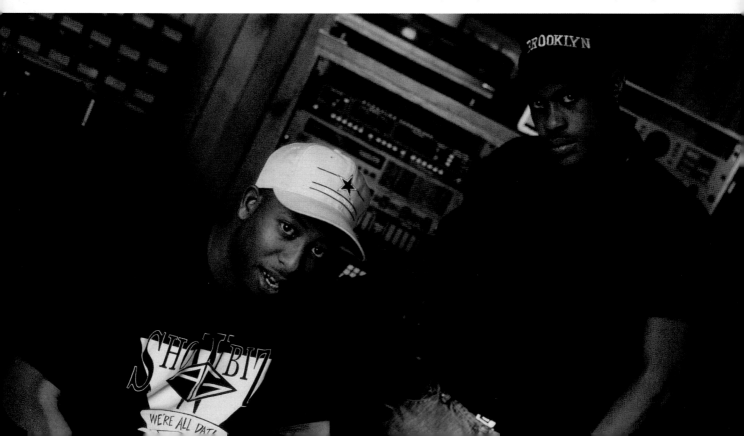

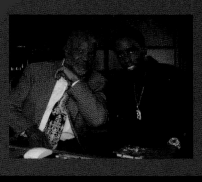

Left: Berry Gordy and Puff Daddy
Daddy's House, New York, 1997
Below: Timbaland, 1998

Inset: Tone and Poke of Trackmasters, 1997
Grandmaster Flash, New York, late Eighties.

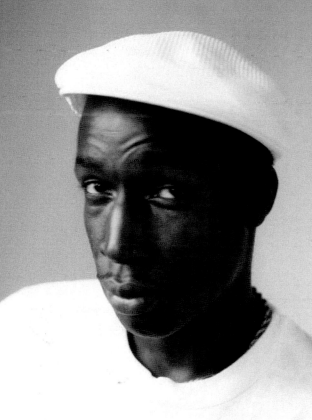

You got a problem?

R B

Rap might've killed off R&B entirely if it hadn't been for rap's utter indifference to love songs. In practice, this stark division of labor—rap is for guys, R&B is for girls—has worked to the benefit of both idioms. Puffy cushioned Biggie's rough raps with Total's sweet vocals from the very start of his career, a tactic that was key to Biggie's universal appeal. On the other side of the rap/R&B divide, it was largely Bobby Brown's b-boy attitude that earned him a solo career after the demise of New Edition. Here in the 21st century, the "thug-love duet," in which the rapper 50 Cent teams up with the singer Olivia, is commonplace. Michael was there with his camera when the two camps first started to mix it up

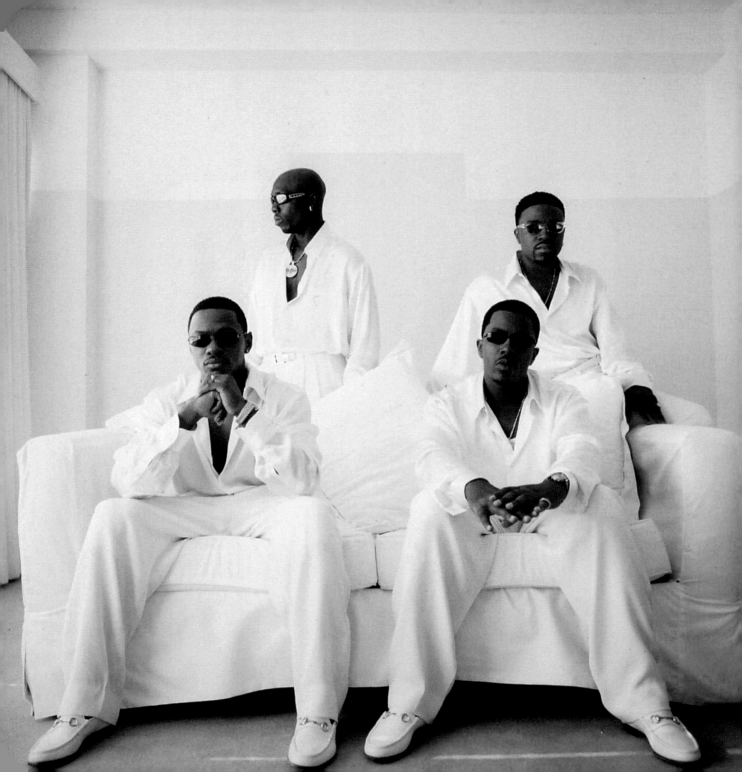

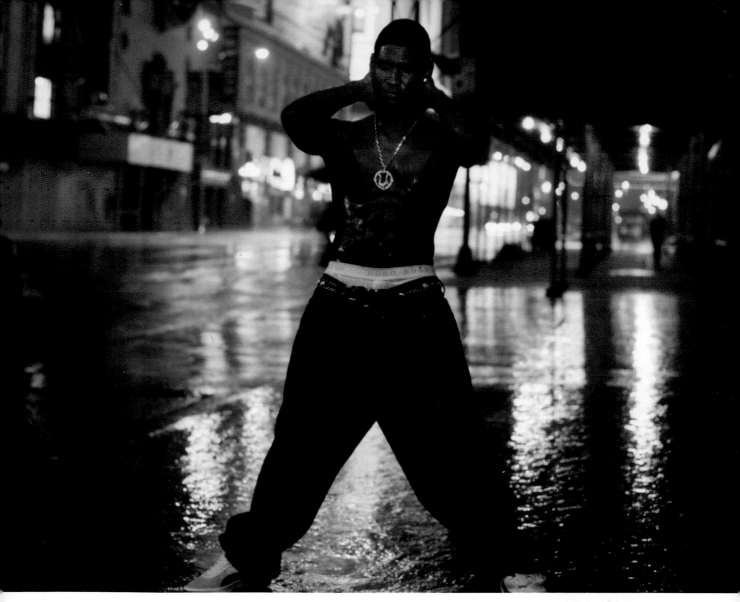

Above: Usher, Times Square, New York, 1998
Right: Usher, New York, 1998
Facing page: Black Street, Los Angeles, 1992

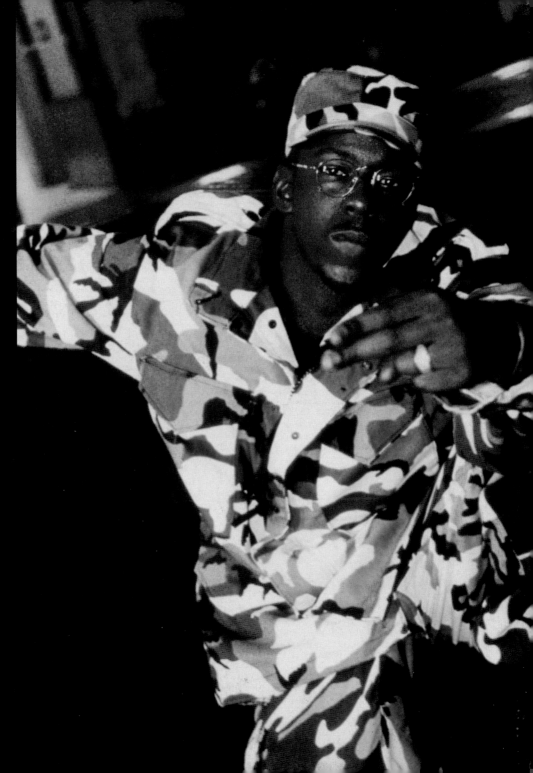

Bobby Brown, Hit Factory, New York, 1996

Bobby Brown, Hoboken, NJ, 1995

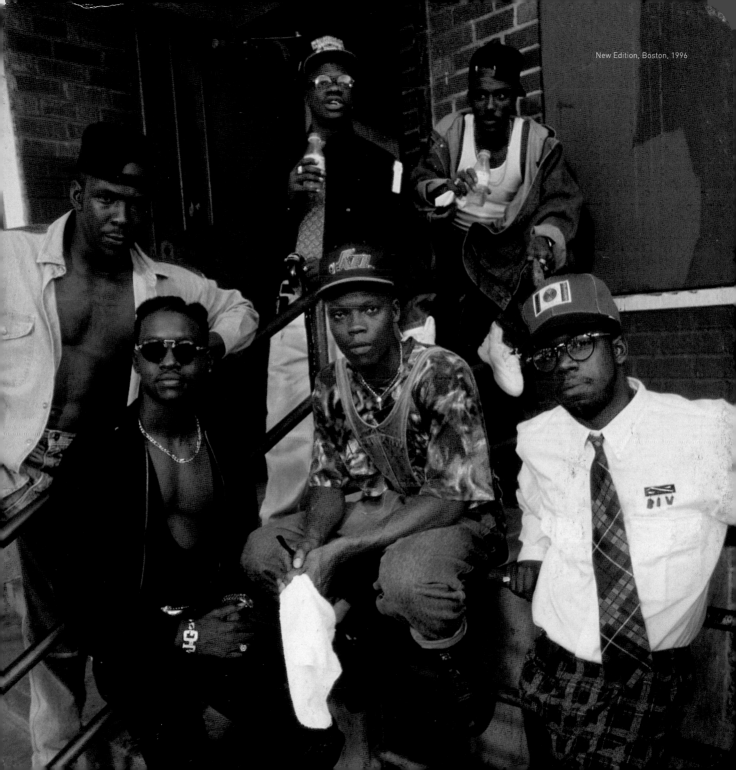

SKOOLIN'

In retrospect, not every session in Michael's career falls into a neat little category. This is a chapter devoted to notable artists whatever their label affiliation.

But first two exceptions to the rule: **Chubb Rock** and **Kid'n'Play**, both of whom recorded for Fred Munao's Select Records, as did the Real Roxanne, UTFO, Whistle, M.O.P., King Just, A.M.G., and the Jerky Boys. Born in Jamaica in 1968, Richard Simpson was a National Merit Scholar who dropped out of a pre-med program at Brown to begin his recording career at Select as the hard-rhyming Chubb Rock in 1988. Kid'n'Play, whose first album also dropped in 1988, were Salt'N'Pepa's matching bookend; both acts were produced by hit-making Hurby "Luvbug" Azor.

The Fat Boys and **Ed Lover & Doctor Dre** were united not by their label, nor their producer, but their manager, namely, Charlie Stettler, a gregarious hardworking hustler from Switzerland. Friends from Brooklyn's East New York, The Fat Boys won their Sutra recording contract in an open competition in 1983—a story dramatized just a couple of years later in the movie *Krush Groove*. They were very popular for several years. In 1995, Buffy died of a heart attack at the age of 28. Ed & Dre were first paired up as co-hosts of the daily version of *Yo! MTV Raps* by Ted Demme, the show's producer, in 1989. After *Yo!* ran its course, the two moved into morning radio in Los Angeles and then New York . . . and even got to make a movie.

Although the Fat Boys made better records, **Doug E. Fresh** had every right to dub himself the *Original* Human Beat Box in 1984. Doug's popularity peaked when he invited a young rapper who called himself MC Ricky D—later better known as Slick Rick—to rhyme on

departed for a solo career.

A Nineties version of the Jackson 5, the aptly named **Immature** were comprised of a trio of ten-year-olds when they emerged out of Los Angeles in 1992. The group had a decent run for half a dozen years and served as a launching pad for lead singer Marques Houston, who's gone on to a career as a television actor, songwriter, and producer.

Ghostface Killah, a/k/a Tony Starks, was, of course, one of the original members of the Wu Tang Clan. His firs solo abum, called *Ironman*, came out in 1996. Michael shot him around the time of the release of his second album, *Supreme Clientele*, in 2000.

New Rochelle's **Brand Nubian** were devotees of the Five Percent Nation of Islam and the righteous herb. Michael shot them for the cover of *High Times* in 1992.

Like Redman, Keith Murray, and K-Solo, Brooklyn's **Das EFX** were protégés of EPMD. The beloved creators of an piggity playful, iggity-influential rhyme style, Drazyz and Skoob were in the first flush of their fame when Michael shot them in 1992.

Pete Rock & CL Smooth made their biggest hit with "They Reminisce Over You (T.R.O.Y)," a 1992 memorial to Troy "Trouble T-Roy" Dixon, a member of Heavy D's Boyz who died in a freak fall on tour and who hailed, like Pete and CL, from Mount Vernon, New York.

Yes, he pioneered sexy lyrics in rap. Yes, he popularized the rhythm called Miami bass. But never let it be forgotten that **Luther Campbell** started out as an indie record man. It was Luke Records that released *2 Live Crew Is What They Are* in 1987, *Move Somethin'* in 1988, and *As Nasty As They Wanna Be* in 1989.

Above: Ed Lover and Doctor Dre, New York, 1993
Facing Page: Ed Lover and Doctor Dre, Tribeca, New York, 1991

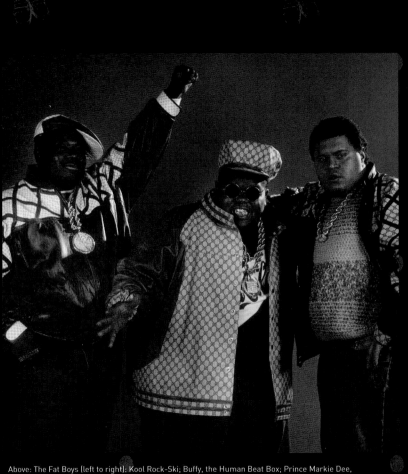

Above: The Fat Boys (left to right): Kool Rock-Ski; Buffy, the Human Beat Box; Prince Markie Dee,
New York, 1987.
Facing page, left to right: Prince Markie Dee, Kool Rock-Ski, Buffy.

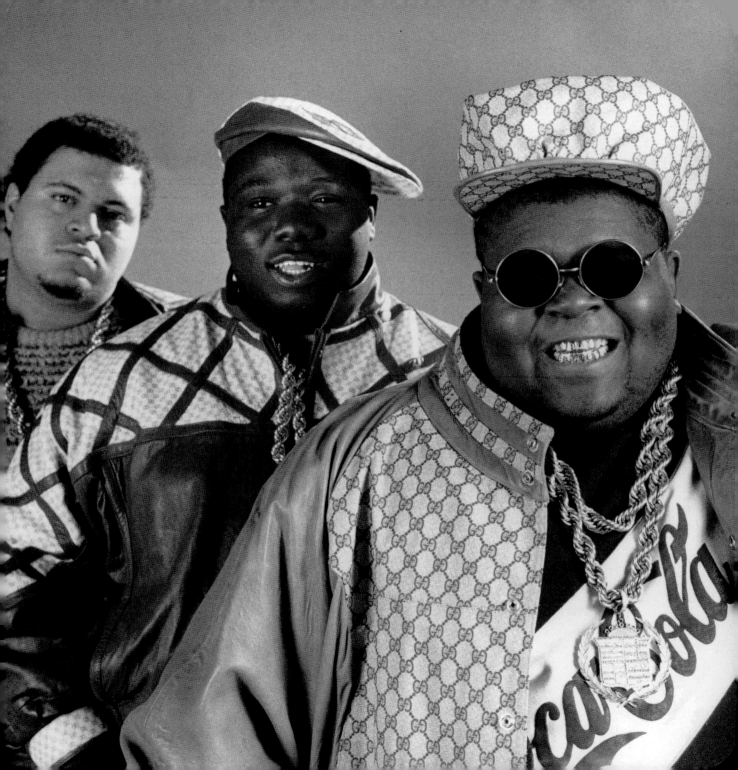

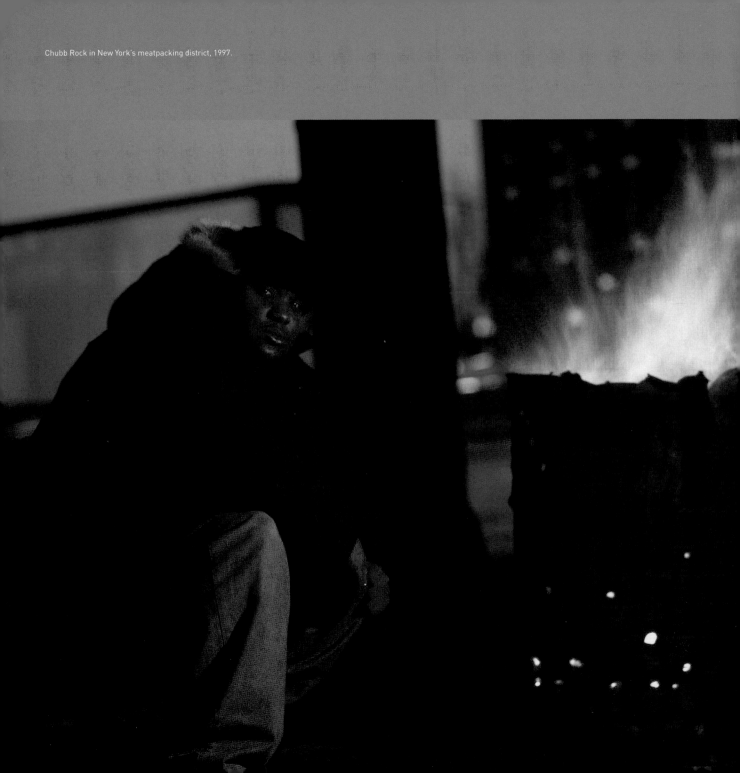

Chubb Rock in New York's meatpacking district, 1997.

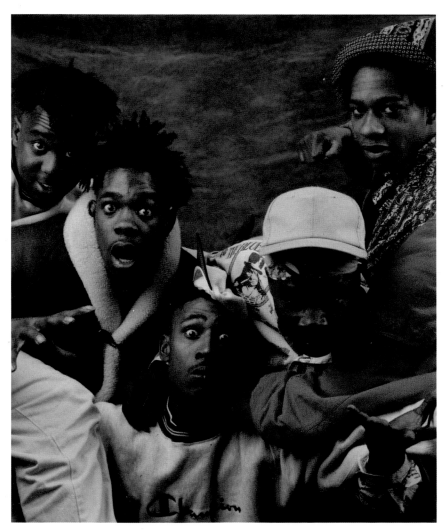

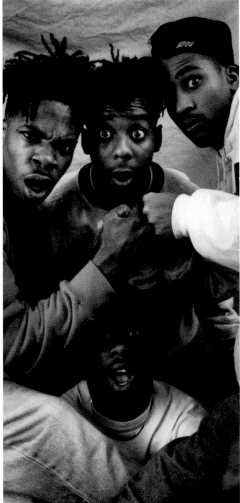

Leaders of the New School, New York, 1991.
Busta Rhymes is second from the left in the photo
on the left and top left in the photo on the right.

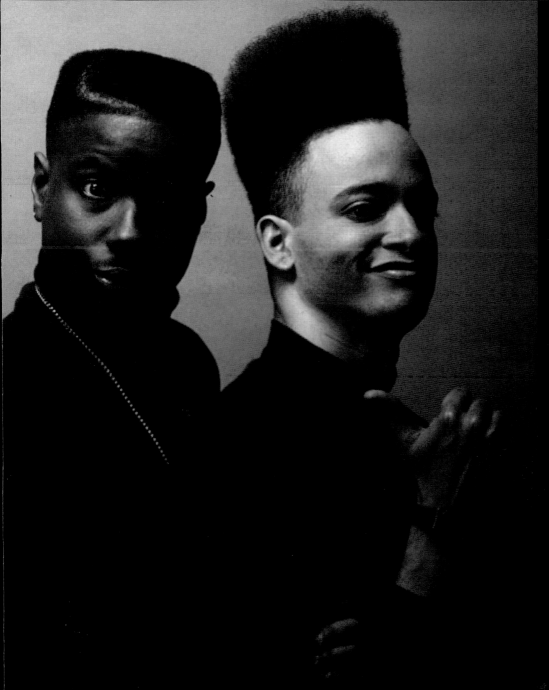
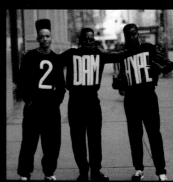

Kid'n'Play, New York, 1988.
Inset: with DJ Wiz.

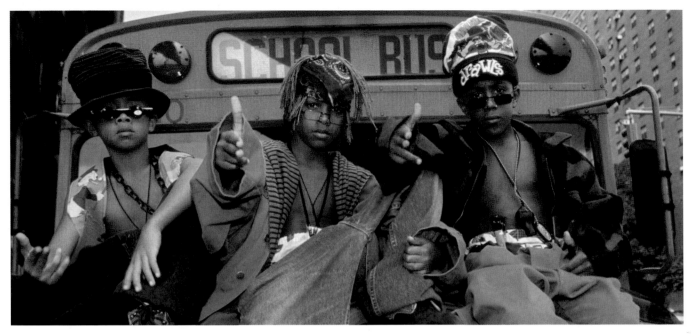

Above: Immature in New York, 1992, Marques Houston on the right. Below: Immature in New York, 1997, Marques Houston, center.

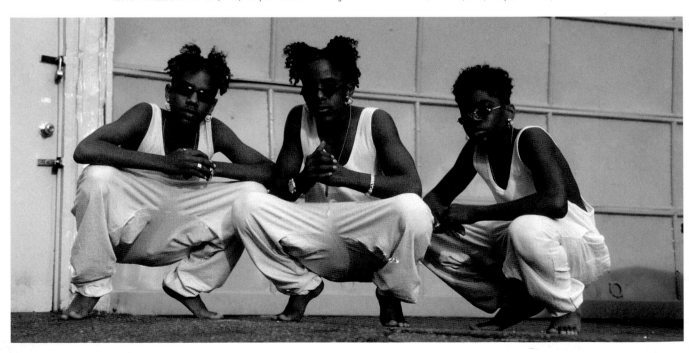

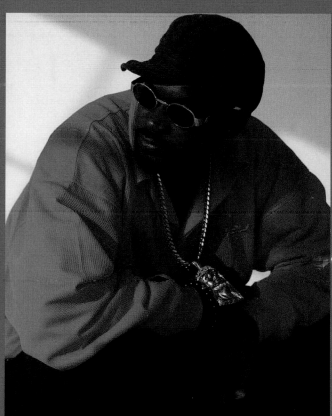

Ghostface Killah, New York, 2000.

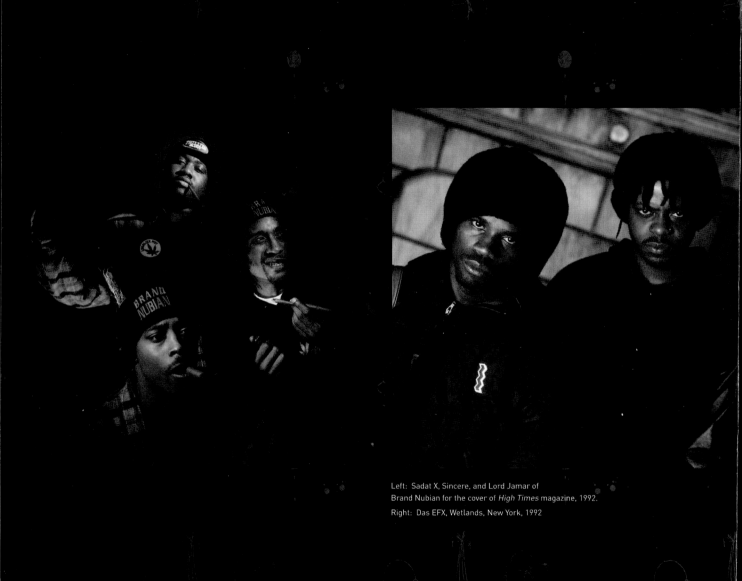

Left: Sadat X, Sincere, and Lord Jamar of
Brand Nubian for the cover of *High Times* magazine, 1992.

Right: Das EFX, Wetlands, New York, 1992

CL Smooth and Pete Rock, Mount. Vernon, New York, 1992.

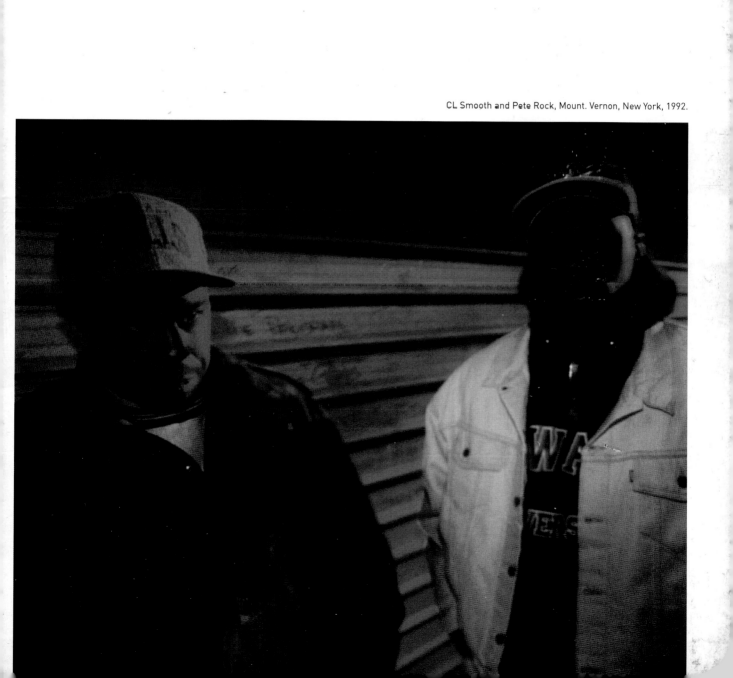

Luther Campbell, a/k/a Uncle Luke, and friends on the set of Biggie Smalls's "One More Chance (The Remix)" video, New York, 1995.